Film Production For Newbies

by
Rick Bennette

Copyright 2017, Rick Bennette.
All rights reserved.

ISBN 978-1541369887

Published by Beeline Publishing
Tequesta, Florida
www.beelinepublishing.com

Dedications

This book is dedicated to the many people from whom I was able to study and learn most of the craft of writing, acting and film making.

My most important dedication goes to my wife, who firmly supports me in every manner.

For screen writing, I thank Richard Zavaglia of the Burt Reynolds Institute for Film and Theater (BRIFT) in Jupiter, Florida.

For acting, I thank Burt Reynolds of BRIFT for his well imparted wisdom. I also thank David Cole and Bob Barron of the Weist Barron School in New York City (now in NJ).

For improvisation, I thank Todd Vittum of BRIFT.

For film production, I thank my mentor, Frank Eberling, for his well imparted knowledge and the privilege to work on his feature film.

I also thank Steve Mairano for his faith in me to shoot and edit his feature film.

To my students:

During your use of this book, should you encounter any errors, or feel that something else should be included, please feel free to email your concerns to beelinepublishing@gmail.com.

The author makes updates on a regular basis, and looks forward to your input.

Preface

This book was written for the beginning film student. Yet, even intermediate film makers might find some of the information useful. It is the goal of this book to cover every aspect of film making. We concentrate upon the basic fundamentals of what is needed to create your first, short film.

This book begins with formatting and writing your script. Acting is covered briefly. Since most readers of this book will likely be making the film, there is more coverage on cameras, lenses, lighting and sound recording. Basic editing skills are covered, emphasizing on data management.

This book is written to be easily understood. Once the basics are understood and practiced a few times, most film makers will automatically progress on their own, perhaps well beyond the scope of this book.

When you find a subject in this book that you think may not be complete, please keep in mind this book was written for beginners.

Table of Contents

Chapter 1 – Why Make a Film?.................................1
Chapter 2 - The Script..5
 Copyright and Ownership..................................5
 The Format of Scripts...9
 Tell Your Story..19
 Writing For Your Resources............................22
 Review. Edit. Repeat...23
 Locations..24
Chapter 3 - The Actors..25
 What is Acting?...27
 Timing..30
 From Stage to Screen..33
 Getting Into Character......................................36
 Conduct on Set..40
 From Standby to Cut...43
Chapter 4 - The Storyboard....................................45
Chapter 5 - Lighting..49
Chapter 6 – The Camera...55
 Learning your camera.......................................55
 Film Verses Video ..61
 Camcorder Components...................................65
 Lens Types...67
 Focus..71
 Lens Apertures and F-Stops.............................74
 Lens Distortions..85
 The Image Sensor...90
 Frame Rates..98

Recording Quality...102
How Is Color Reproduced?................................108
Depth of Field..110
Dynamic Range...112
White Balance...114
ISO and Video Gain..119
Exposure Techniques..123
Chapter 7 – Creating Shots......................................129
Framing Your Shots ..129
Shot Composition..135
Chapter 8 – Recording Sound...................................137
Microphone Types..137
AGC and Limiter...146
XLR Connections..147
Internal or External?..150
ADR and Looping...151
Slating and Logging Shots..................................153
Chapter 9 – Editing Your Film..................................157
Good Data Housekeeping...................................161
The Editing Time Line..169
The Master Data File...172
Your First Edits...178
Adding More Video..185
Creating Fades..187
Adding Music...188
Split Cuts and Video Inserts...............................190
Adding Titles..191
Rendering Your Project......................................194
Going Further with Editing................................197
Chapter 10 – Marketing Ideas...................................199
To my students:..203
More Books...204

Chapter 1 – Why Make a Film?

People make films for many reasons.

Make movies because you love the art of creation. Do it because you enjoy the process. Relish the opportunity to participate in a collaborative project with like minded friends. Let the realistic dream of hosting a movie premiere at a local theater full of family, friends and local patrons be one of your driving motivations.

Like anything, if you spend enough time writing and making films, you'll become more proficient at telling your story through the medium of film. Or in this day and age, to be technically correct, high definition video. Regardless, we still call it a film. Who knows? Maybe you'll end up becoming the writer or producer of the next great blockbuster.

Consider the 1999 film, 'The Blair Witch Project'. A small, independent group of film makers created the film using home video equipment. Blair Witch was made before the

days of high definition video. The plot wasn't very complicated, and the cheap production made the film look fuzzy and shaky when projected onto a large screen.

The production budget was in the order of about twenty thousand dollars. Most of that was probably for permits, insurance and props. Yet, the film went on to earn 248 million dollars at the box office. Why?

Blair Witch Project was the first film of its kind. Everyone wanted to see how a home made film, created using student actors, a six hundred dollar home video camera, and a few scenes on black and white 16 millimeter film could have made it into mainstream theaters around the Country. I was one of those who was curious.

The film was well marketed. It was one of the first to have been done so via only the internet. There were no broadcast TV trailers with musical crescendos and resonating vocal tracks. Fliers were passed out at local film festivals asking anyone with information on the missing student film makers to please come forward.

A purposeful debate was made as to whether the film was a true documentary of student film makers who really went missing in the woods, or if it was just a well thought out promotion for a low budget horror film.

The situation of missing film makers is never openly admitted as real or fake. The fact that the film makers were interviewed later lends credence to a well crafted promotion.

Success stories like this are rare, yet they drive many film makers to create movies based upon the hope that similar success will come to them.

The advent of inexpensive, high definition video cameras made it possible to create technically decent films by millions of film makers around the world. Consequently, with so many new indie films being made each day, it's difficult to command high dollars for all but a select few of the most well promoted. In this business, good marketing is often more responsible for financial success than a well made movie. So go ahead and make your film. Make it because it's just so much fun.

That being said, there is plenty of potential in making commercials for local businesses.

In the past, the only place to air commercials was broadcast television.

Today, commercials are playing all over the internet. Facebook, YouTube, individual web sites and local television stations air more commercials now than ever before.

With modern high definition video cameras costing less than a thousand dollars, it is possible to produce creative commercials in the 500 to 1000 dollar market and still make a profit.

Chapter 2 - The Script

Every film, no matter how short, begins with a **script**. The script is the road map used by every actor to guide their dialog, their mood and their actions. It also aids the producer, the camera person and every other person on the production team. One might say that the script is the written vision of the finished film.

Copyright and Ownership

I'm not an attorney, nor is this legal advice. I am passing along information I gathered from the US government web site, www.copyright.gov regarding copyright law.

Knowing this information can prevent the need for adverse action in the future.

Copyright gives the owner of a script (and many other works) the exclusive rights to market, sell and distribute their work. They may assign full ownership rights to another party, or they may allow the rights to use, copy or distribute their work while still

retaining ownership of their work. This is done through licensing.

Copyright law stipulates that the person who creates the tangible work is the copyright holder.

When you write a script or shoot a film, the copyright and ownership of that work automatically belongs to you. Copyright occurs as soon as you affix your work onto any medium. The medium can be a memory card, a hard drive, a printed page or a hand written document on a paper napkin. You own the work and the copyright until you assign those rights in part or in whole to someone else through a written instrument (a contract). Writers do this when they sell their script to a studio.

Some writers work on the basis of **work for hire**. Work for hire indicates that you are an employee of someone else. A staff writer employed by Universal Studios hired to create scripts does so for a salary. Even though he writes the script, his being an employee of Universal Studios in the capacity of a writer automatically assigns copyright to the studio.

When you film a wedding for a client, you are considered a vendor. You are not an employee, so work for hire does not automatically apply. You still own the copyright to your work even though the client paid you for it. The client is buying a **license** to use your work for his or her personal enjoyment.

The only way that copyright transfers from vendor to client is through a written instrument clearly assigning copyright. It can not be verbal, nor can it be assumed just because you were paid for the work. This means if the client uses part of their wedding video on a TV show, they must first obtain your written permission to do so, or they are in violation of your copyright.

Likewise, you can not use the images of another person for commercial broadcast use without their written permission. This is most often done through use of a written instrument called a **model release**. A model release gives you the right to use their images in your commercial work.

Most short films have virtually no market value, so in most cases, copyright does not

become an issue of contention. You may simply place the copyright line on your script, or take it one step further and register your work with the copyright office. In the rare instance your work suddenly becomes popular and generates large amounts of money, you would want to have your copyright and model releases in place to protect your exclusive rights to sell and distribute your work.

Copyright laws are federally governed and enforced only in federal courts. There is no small claims court for copyright law, hence, it's an expensive legal process.

The US government web site will provide detailed information beyond the scope of this book regarding copyright law of scripts, films, books, etc. Additionally, you may contact a copyright attorney if the need arises.

The Format of Scripts

There is no mandatory requirement to use any particular computer program to create your script, but Hollywood convention does set formatting standards that are used by the film industry. A professionally formatted script tells the reader that you know what you are doing. The proper page format allows a producer to quickly view the script and assess the scope, budget and length of the film. A non professionally formatted script will not allow this as easily.

Final Draft is the industry standard software for creating scripts, but it is costly. Free software called **Celtx** creates scripts that will also meet industry formatting standards. It's commonly used by film students because it's free. Celtx can be found and downloaded on line at no cost.

The following illustration shows a page of an industry standard script, along with descriptions. Thanks go out to The Writers Store for this page.

```
The standard script font is 12 point
courier because it is easy to read.
```

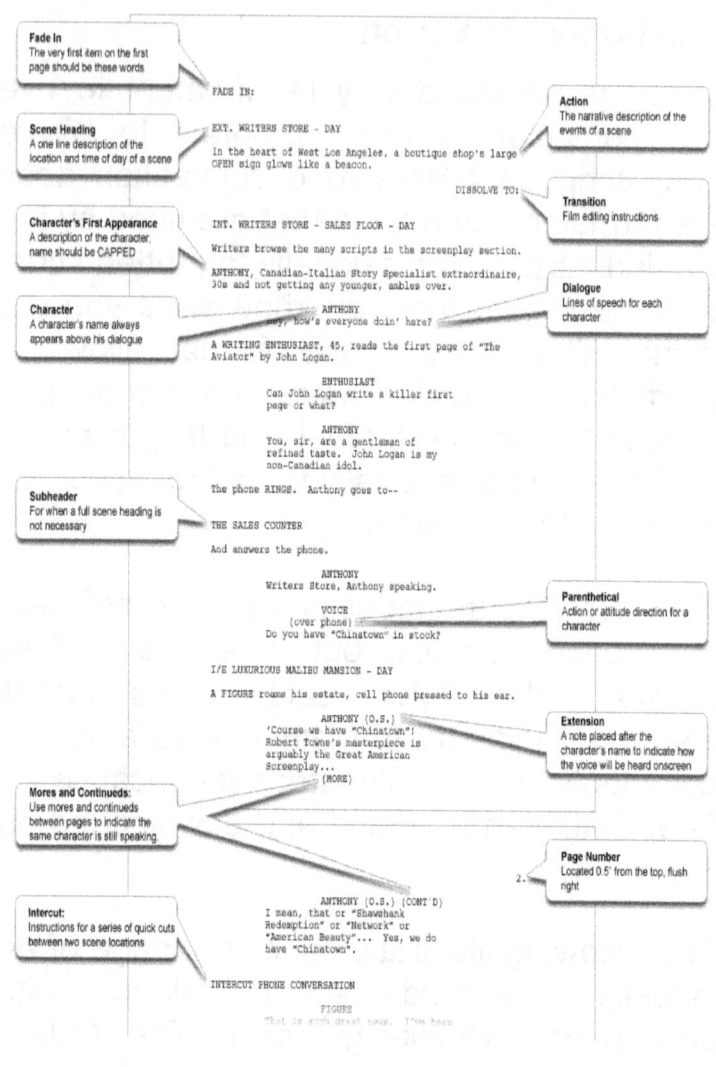

A typical industry standard page of a screenplay.

The screenplay begins with the words Fade In at the upper left corner, indented ½ inch from the page margin. This signifies the beginning of the film.

The **Scene Heading**, also called the **Scene Slug**, is also indented ½ inch from the margin. These always begin with **INT** to denote an **int**erior (indoor) scene, or **EXT** for **ext**erior (outdoor) scenes. The next few words tell the basic location where the scene takes place, and the final word(s), separated by a hyphen, tell the time period of the scene.

This information helps the director determine what lighting and other equipment might be needed, and also provides a rough estimate of the budget. For instance,

INT - Coffee Shop – Day

This scene heading will usually indicate an inexpensive scene to film, simply because you only need a table and chairs as a set.

EXT - Mountain Top – Late Night

This scene slug would indicate an expensive

scene requiring transport to the top of a mountain, a good deal of lighting equipment, prepared meals, heating equipment, emergency standby services, etc.

The **Action Block** provides the text for the setting of the scene. It is also indented ½ inch from the left margin. Since movies are made to *show* action, not *tell* it, we refrain from using lofty descriptions in the action blocks. We stick to only the basics the director needs to know about the scene and situation. For instance, we would not write:

> SUSAN walks onto a rolling field thick with soft, Kelley green, sweeping rivers of grass.

Instead, we would write:

> SUSAN walks onto a grassy field.

The film itself would show the dramatic, sweeping rivers of grass.

The character NAME in the action block text is written with all capital letters. This is always done in the action block whenever we use the character name, or reference to the

character, such as HE, HER, SHE, HIM, etc. for the first time in the block. This calls attention to the actor that this is where they will find their blocking instructions.

The actor's

NAME

is capitalized below the action block and centered on the page.

An instruction called a **parenthetical**, often called a **wryly**,

>STEVEN
>(apologetically)

is sometimes used to denote the attitude or direction of the actor. It would be written in parentheses just below the actor's name. There is a strong tendency for beginning screenwriters to overuse wrylies. They are best used sparingly, only when the dialog can't convey the information.

The initials OS placed after the name, n parentheses, indicates the actor speaks off screen.

DANIEL (O.S.)

The actor's dialog block is indented about an inch and also centered on the page. This makes it easy for the actor to find their dialog from the rest of the information on the page.

Sometimes a **transition** is used to indicate to the editor how to bring the scenes together. These transitions, such as

DISSOLVE TO:

are capitalized and written to end at the right margin.

Other less used directions can be found in more thorough screen writing books, but these are the basics to get started for your five minute film.

Don't worry too much about remembering all the formatting information. The screen writing software does it automatically, so it's well

worth it to use special software and not attempt to use something like Word, where you'd have to do it all manually.

Most of the remaining page descriptions are quite self explanatory, simply by reading their labels.

At the end of your script, you'll add the words, FADE OUT to indicate the end of the film.

Formatting the pages in the manner described helps each person more easily find the information that is important to them.

Formatting in this manner also allows for an estimate of about one page per minute of film. In this manner, the director is able to assess the total length of the film in minutes simply by seeing the last page number.

Proper page formatting also makes your script look professional. But even a perfect, professionally formatted screenplay can not make up for a poorly written story.

Movies are created, in most cases, to tell a story. The best way to tell a story is to have

the script flow smoothly and methodically, regardless of the type of story being told. You must keep in mind the audience will only get out of the film what is put into it. They can't read your mind and assume the things you know about your film.

There's an old expression that says, if it ain't on the page, it ain't on the stage. If it's important for the story, you need to write it into the script. Don't assume anyone can know what you know if you don't write it on the page.

Most story and character information is often provided in the dialog rather than in the action box.

You don't need to over write the visual things that are obvious to the viewer.

You wouldn't need lines telling that Debra's hair is red or her dress is black. The image itself will show that.

Sometimes the color of a particular piece of clothing is important to the story. If it is, then it must me made known in the action block.

Debra, wearing a red dress, enters the room as the song 'Lady in Red' begins to play.

It's best to allow the characters to tell the story rather than have the action blocks create too much of an exposition.

Seldom will the action block inform the audience that John is 39 years old. Instead, the character might say,

>DEBRA
>
>So you're finally you're turning forty next week. And you didn't invite me to the party?

People in real life don't speak perfect English. You can give your characters their own voice by intentionally using slang, contractions, misspelled words, or expressions that don't make sense to anyone else.

>MARVIN
>
>He done dug dat hole

in da sand, I gotta say,
he done it fine.

Tell Your Story

The beauty of writing is that you can select any genre and situations you like. Romance, comedy, action, drama, documentary, or perhaps a combination of these, will usually make an interesting film.

Of course you are free to write as you like, but the films most viewers prefer will follow a prescribed pattern that keeps them entertained. This is done by introducing **conflict** and **resolution** between the goal of the main character, (the **protagonist**), and something in the way of that goal (the **antagonist**).

The antagonist does not have to be another character. It can be an object, an incident, a mood, or an animal.

For instance, in most romantic films, there's a guy who wants the girl. The antagonist might be a former love interest. Or it might be that the girl doesn't like the guy because she thinks he's a womanizer. It could be the girl's dad who thinks the guy isn't good enough for his daughter. Maybe the guy is just about to propose, when an urgent call

comes for him to run off somewhere for an emergency situation, leaving the girl to wonder about his true intentions. The antagonist would be her doubt.

A short film or a single scene might only need a single conflict. Longer films often contain a rising and falling sequence of many conflicts. Below is a common scenario of probably half the romantic comedies ever made, showing the rise and fall of conflicts.

The guy pursues the girl. She isn't interested at first, but eventually falls for him. Then she sees him kissing someone else and leaves him. She later learns it was just a friend returning from a long absence. She forgives him, only to discover after she left him, he began dating someone else. He dumps the second girl when he finds out the first girl still wants him. They kiss and make up. He asks her to marry him. She says yes. Her dad disagrees, but she runs off to marry her boyfriend anyway. Dad sabotages the boyfriend's car, and the boyfriend misses getting to the church on time. The girl waits but leaves angry after he fails to show, only to find out later it was her dad's doing that caused her groom to miss the wedding. Dad

finds out the boyfriend is really an OK guy, gives his blessing, and the wedding takes place in the final scene.

Regardless of the conflict, there must be a believable resolution by the end of each scene and the end of the film. The guy gets the girl. Or the girl goes off on her own and the guy comes to terms will being free so he can spend his days with his buddies.

Films that depict scenarios people can relate to will draw the widest number of viewers. It's why romance and drama are successful. Most people can envision those everyday events happening to themselves, and in most cases, it already has.

Science fiction allows you to rewrite the rules of the real world. Just because you have the freedom to create a scenario or character, like a hero who can deflect bullets, you need to always retain consistency within your own rules. If in one scene, the hero can deflect bullets, you can't have them suddenly die of a gunshot wound without a plausible explanation of why that rule changed.

Writing For Your Resources

When writing your script for a zero budget film, you are often confined to writing for the resources you have at hand. In other words, if you write a script that you intend to shoot with no budget, you can't write scenes with building explosions or crashing airplanes.

You may be confined to working with only the actors in your class. It would be difficult to portray a sixty year old man if all you have in your group are two women and a teenage male. If you are writing with no budget, and intend to film your scenes with volunteers, then it's best to write scenes that cater to the free resources you have at hand.

Another consideration is how much time that will be allotted toward making your film. This book was specially written to accompany an eight hour film course. As such, many details are omitted simply because there would not be time in an eight hour course to cover them. Students are not likely to complete a film longer than a few minutes within the eight hour time frame of this class, unless they decide to work on their own time after the class has ended.

Review. Edit. Repeat.

It would be nice to reach the end of writing your story and say, 'OK, let's film this'. But completion of the writing is only the first phase. Now it's time to find and correct the misspelled words, smooth out the lines so they slide easily off the actor's tongue, and perhaps rearrange the order of events to make the story flow nice and smooth.

You are not likely to notice all the errors right after writing the script. Once you've written your first draft, allow it to sit for a few days, and then read it again. Read it out loud into a recorder, even if it's just your phone. Play it back and see if your script seems to follow your vision. Does the dialog flow? Are some lines tongue twisters? Does the dialog sound like real speech, or more like a proper sentence from an English book?

Rewrite your script, edit it and repeat. Pass it on to colleagues for feedback. You may need to trim excessive scenes that drag on, or add new scenes to clear up confusion in your plot. If no one other than you can understand the intentions of your story, it might need some rewriting.

Locations

Locations are another consideration for writing your script. Chances are, you'll have limited places to shoot your film. Avoid writing scenes that take place at a location you won't be able to use.

Legally, you can't use private property without the owner's written permission. If you're filming on public property, you'll need to obtain a permit from the town or county. You'll find this information in the film commissioner's office of your local area.

Creating your own sets is great, but in a short film class, this won't be practical. Use the rooms and props that are already there.

You will also need insurance if you film in locations beyond your school facilities. Most schools have limited insurance, but only on premises, so you can shoot under their policy if you follow their rules.

Some film makers take the risk of shooting on their own with no insurance, but this exposes them to high liability in the event of an accident or injury.

Chapter 3 - The Actors

Acting is a form of art. It is perhaps the most variable of all facets of your film. Budget film makers often have to select their actors from the group they are working with, or from their friends.

Casting takes a good deal of time. Actors who aren't your friends may expect to be paid. In some communities, you can reach out to your local theater group and find actors more than willing to participate simply for the fun of it, and for a film credit. Local film maker groups on Facebook and local acting schools are also good places to find willing actors.

Most indie film actors are non union, and therefore, cast and crew are free to work without payment. Actors belonging to the Screen Actors Guild (SAG) are required to be paid a minimum daily rate, a hot meal on set, and the use of a private facility for changing into costume.

All actors should sign a model release form if

they are 18 years or older. Under 18, their parents should sign a release form allowing their likeness to be used for commercial purposes.

The last thing you want is to finish your film, then have an actor prevent you from using his or her image because they didn't formerly agree for you to do so. Perhaps you've had a falling out, and they change their mind about being part of your project.

If your film becomes a financial success, some actors may come back later demanding an enormous residual payment to appear in your film.

A written model release will alleviate all those concerns and allow you to focus your efforts on creating your film.

Likewise, you'll probably want to have written agreements with your crew for the same reasons.

What is Acting?

Acting is the art or profession of the realistic performance of an imagined character. This is in contrast to the belief of some that acting isn't the truth. Indeed, acting is the truth. It is the truth of a character or a situation that the writer has created. While the character may be made up in the writer's mind, the performance of that character by the actor is always true and real.

Acting involves much more than simply memorizing lines and reciting them on cue. The tone and the mood of the scene will also need to be well understood. Emphasis placed upon certain words can convey completely different meanings, even when the same words are used.

Consider the following short sentence, "I didn't do that to her." How many ways could this be stated? An inexperienced actor might simply say all the words with equal emphasis. Without proper emphasis as created by the writer, this statement could convey something ambiguous to the audience.

Let's look at the following examples of what the correct emphasis on just one word in that sentence can convey.

By placing emphasis on the word **I**, the actor will convey that they, as opposed to someone else, didn't do something. "*I* didn't do that to her, *he* did."

Emphasis on **didn't** changes the meaning of that same sentence. Having been accused of doing something to the girl, the actor responds, "I *didn't* do that to her, even though you think I *did*."

Again, with another word emphasized, another meaning is portrayed. "I didn't *do* that to her. I may have *thought* it, but I didn't *do* it.

And again, I didn't do *that* to her, I did *this*.

Or, "I didn't do that *to* her, I did it *for* her."

And lastly, I didn't do that to *her*, I did it to *him*.

By this simple exercise, we can see that by emphasizing only **one** word of the same

sentence, an actor can convey **six** different meanings.

Timing

Often the **timing** of the delivery, or strategically inserted pauses, can completely change the tone of the words.

When the writer intends for a pause to exist between one actor's statement and the other actor's response, this will be indicated by what is called a **beat**.

>SUSAN
>
>Were you involved in that incident?
>
>ALEX
>
>No. (beat) I wasn't.

The beat, or pause of Alex's response, gives rise to Susan (and to the audience) that Alex may not think Susan believes he is telling the truth, even though he says the correct words.

Sometimes, a powerful message can be delivered without the actor speaking a single word. This was brought to my attention in the very first few minutes of my first acting

lesson in New York.

There were perhaps twenty students in the room waiting for the instructor to arrive. He walked into the room, introduced himself to the class, and asked us to count the light fixtures in the ceiling. He then sat down on a stool and waited for us to carry out his direction.

Needless to say, most everyone sat in their seats looking up at the ceiling and mentally counting light fixtures. I had never taken an acting lesson before, but of course I had seen movies and shows. I knew the instructor didn't give a hoot how many fixtures were in the ceiling. He could have easily counted them himself if that was the importance of his question, if he hadn't done so already at some other time.

As I observed the other students quietly making their mental notes, I rose from my seat and scat about the room. I pointed my hand up at the ceiling, slowly at first, then advanced around the room ever faster, pointing more abruptly as I progressed in my imaginary count of the fixtures. Midway through my process, I stopped, paused and

returned to the corner where I had originally started. I began repeating my imaginary count, but a little faster this time. About halfway into the process, I stopped again, threw my hands into the air, and waved them frantically as I shook my head. I went back to my seat.

The instructor began to clap, then the rest of the class joined in, not really knowing why. The instructor than told the class that only one person 'got' what he was looking for. It wasn't the real number of lights that was important at all. It was the process and making a mockery of it.

Had this been a directed scene, the written instructions to move about the room pointing ones arms and waving them in frustration, would be known as **blocking**. Blocking is simply the instruction given to the actor for his or her movements about the scene.

A more common blocking instruction would be:

Susan enters the room and turns toward Alex.

From Stage to Screen

Film acting is quite different than theater acting on a stage. Acting for the theater often involves a loud, projecting voice and bigger than life body movements. This is because the dialog and action must be projected all the way to the last row in the theater so every audience member can see and hear what is being portrayed. For film production, nothing could be worse than these big actions, as they would appear too contrived and false.

In film, the camera and the microphone do most of the work bringing the action close to the viewer. Ideally, the actors will need to be aware that minimal body motion is needed in most cases, otherwise the actor may move out of frame or out of focus. The camera operator will see this in the video monitor immediately if it happens, but no one else will.

Often, a small change of expression and a small volume of voice goes a long way to providing the drama needed for a scene. Work with your actors in reinforcing the old film adage that 'less is more'.

Allow new actors to see and hear themselves on the playback of a scene if time permits. Usually, this is done during class settings, as once the film is in production, stringent time constraints do not permit playbacks.

A major consideration is having your actors be able to read their lines **off book**, that is, memorize them well.

Unlike a play, an actor can review their lines before each scene, and commit perfect memory only to their lines once scene at a time. This comes easier if the actor has had ample time to memorize the entire script.

Often, the writer continues changing lines right up until the shoot. Actors may not be able to keep up with memorizing the latest changes. If you are the writer, allow enough time for your actors to become familiar with the script, and provide your changes to the actors as soon as possible. It helps to have their emails and phone numbers so you can text any changes and notify them right away.

Continuity is key to good scenes and edits. An actor always needs to be aware of scene blocking. This means blocking of the actor

and the handing of props for the particular scene.

In order for the film to be edited properly, the actor must portray the scene exactly the same way for each take. The head movements, body movements, picking up and movement of any props, must all be done exactly the same way each time the scene is shot. If not, then the editing will never look seamless.

If the actor ends the scene in one take with his head facing to the right and tilted slightly, and another take with his head straight up, the editor will not be able to match the takes seamlessly. The audience will see the head jump abruptly from tilted to straight as the edit is displayed.

This is perhaps one of the greatest challenges to beginning actors, because most are simply focused on correctly memorizing their lines.

Getting Into Character

As an actor, it is important to shed your everyday mannerisms and assume those of your character. A good way to get **into character** is to learn more than your lines. Understand what the scene is about. Learn the **five W's**.

Who, Where, What, Why and When?

Who are you? A mean boss, or a timid employee?

Where are you? Outside on a cold day, or in a steamy bedroom?

What are you and your characters trying to accomplish? Are you meandering home for a reunion, or racing somewhere trying to save the world?

Why are you doing this? To enjoy the moment, or to get even with someone?

When is this? Is it the mid sixties, or is it current day? Is it early morning or late evening?

All these factors should play into your character and the delivery of your performance.

Think about portraying a tender scene by a hospital bed where the patient is dying. This requires so much more than just memorizing the lines. The actor must bring forth the heartbreak of watching a loved one about to die.

How does one accomplish extreme feelings on a film set? One of the most common ways is to dig deeply into your own past experiences and draw emotion from them. This is where the actor can either shine, or simply get by without making a mistake.

Does your character need to shed tears? Think about the day someone close to you died. Or perhaps, imagine what it would be like if you got a phone call that someone you loved just died. Think of anything that has ever brought tears to your eyes, and soon enough, you'll get those tears on camera.

Words are written into the script for a reason. Sometimes addition or omission, or the changing of just one word can change the

meaning of the entire scene. A good actor will never intentionally use words other than those that are written. Of course, mistakes happen. Once in a while, the mistake can actually be an improvement over the line as written, but very rarely.

If you do make a mistake and you are aware of it, don't stop unless directed to do so. Even if you flub the line, the rest of the scene might be perfect. The editor can splice the portion of the next corrected take to cover your error.

How do your lines sound to a viewer? Practice recording yourself at home. Can you deliver the lines so they sound like someone is really saying them as they would for real? Or is there a hint of theatrical drama making your dialog sound contrived?

A new actor walked onto set and heard two people engrossed in a conversation. He waited a moment for them to pause so he could ask a question, then apologized for interrupting their conversation. They responded, "no problem, we were just running lines." They were reciting their dialog so realistically, the other actor simply thought

they were conversing. That's when you know it's right.

If you are fortunate enough to have someone in your group who does makeup, this can go a long way toward helping your actors look better on screen. A good makeup artist will be aware that the makeup needed for the camera is different than the makeup which is worn every day. Even the faces of male actors will benefit from a smooth dab of makeup here and there.

Conduct on Set

First time actors will need a lot of hand holding to get everything right. It's often a new experience and learning curve for them. As a director, you need to be aware of this and be patient with new actors. Remember, they might be doing this for free, and they can walk off the set if they begin to feel mistreated. This can cause the need to re-shoot every scene they were previously in. Mutual respect and good manners can go a long way.

In Hollywood, many film sets are created in a studio to emulate the real world while allowing consistent lighting and sound conditions favorable to filming requirements. Your film set will likely be the classroom and its surrounding grounds, or perhaps a fellow film maker's home. As such, there is a requirement of proper conduct that respects all involved in making the film.

The first thing is to honor the time of your fellow cast and crew. Arrive fifteen minutes early and be ready for your task right away. One person arriving late can hold up the entire cast and crew. You may be starting out

working on a zero budget film, but if you wish to continue on a budgeted production some day, people will remember your conduct at the beginning.

Actors may be rehearsing their lines just prior to filming a scene. Do not interrupt that rehearsal, even if they are conducting it on their own. Actors have a self routine that helps them get their head into the scene, and that can be interrupted with something as innocent as a 'hello' at the wrong moment. Wait until an obvious break before conversing with actors.

In the scope of making your first film, cast and crew may be asked to temporarily swap roles at times to accommodate the fact that only four people are on set. Perhaps the camera operator has a short role in the film, and must ask someone else to operate the camera during his scene. While this would never happen on a union shoot in New York or Hollywood, it is common on low budget films.

Always be aware that the guy setting up lights today might play the lead role in a film next week. Honor the position of everyone

you work with.

Regardless if it is someone's home or your classroom setting, you will do well to tread lightly. Do not arrive with muddy shoes and walk on someone's white carpet. Keep the set clean of debris at all times. Don't touch anything you are not asked to touch. This could be a **live set**, meaning that props are in certain places where the actors intentionally left them before a break was called. The continuity of the scene can be adversely impacted if someone else was to move a prop before filming of the scene was completed.

If you are part of the crew, be careful using other people's equipment. It is your responsibility to use the equipment properly and return it to the owner in good, working order at the end of the day. If you drop it or damage it, you can be held responsible to replace or repair it.

During breaks, it is your responsibility to secure the equipment from damage or theft. You don't want to leave yourself open to the liability of replacing someone's equipment because you failed to take a few precautions.

From Standby to Cut

The director will control the activity on set. He or she will determine when the scene is going to be recorded and when recording will cease. A series of verbal cues are issued in specific order to allow the crew to engage the equipment so it is active for filming the scene.

It goes without saying that all **cell phones** must be turned off. Even when set on silent, a cell phone sends out electrical pulses to the cell tower. Those pulsing signals can produce intermittent noise through a microphone system even when the phone is sitting idly on a nearby table.

Usually the director will call everyone's attention that a scene is about to be recorded by issuing the commend for everyone to **Standby**. When you hear this cue, it means you must be ready on set to begin your task. Any talking, rustling scripts, opening candy bars, or anything else that makes noise of any kind must cease immediately. Microphones are sensitive to sounds you might not think they can hear. Even conversing quietly in an adjacent room

can be heard in the background. Hold all conversations for later.

The director of past would often command **Lights** for the lights to be turned on. Today, cool LED lights may be left on for the entire scene because they stay cool, use very little power and last much longer than regular bulbs.

The director then says, **Roll Sound**. The sound person responds, **Rolling,** to signify the equipment is properly recording.

The director then says, **Roll Camera**. The camera operator responds, **Rolling,** to signify the camera is properly recording.

Once the director knows all the technical equipment is recording, he or she will finally issue the command, **Action**. At this point, all actors will begin their rehearsed blocking and their lines. They will continue acting as previously instructed until the director yells **Cut**.

If you are not part of the scene, always remain totally quiet from the time the director yells **Standby** until the director yells **Cut**.

Chapter 4 - The Storyboard

A **storyboard** is a visual aid created to help the technical team get a better idea of the writer's vision. Think of it almost as a comic strip with dialog. There are professional programs for creating great looking storyboards. A professional software package like **Frame Forge** can practically recreate the entire film, right down to the character outfit, camera lens and distance.

Quite honestly, for short, five minute films with only a few scenes, the expense and learning curve of Frame Forge will require resources better spent on cameras and lights. You can do well enough using hand drawn storyboards, even if your artistic ability is limited to creating stick figures. All you need to convey at this time is setting up the sequence of shots, the positions of characters and scenery, and whether shots are wide angle, medium shots or close ups.

Of course, some film makers will always choose to use software to create a storyboard. On the next page is an example

of a simple storyboard made using Frame Forge.

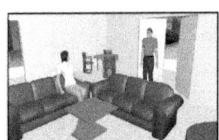
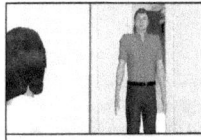
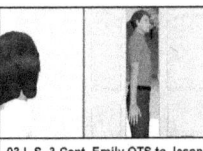

01 E.L.S. 1-Cent. Living Room
There is a knock on the front door.

EMILY - Come in.

Jason enters, stands at doorway.

EMILY - What are you doing here?

JASON - I heard you were - -

h: 5' 6" | f/l: 15.7mm | v: 68°

02 L.S. 2-Cent. Emily OTS to Jason
EMILY - - - terminal. Now please go away.

JASON - I just want to talk. Can I come in?

EMILY - No.

h: 3' 9" | f/l: 32.9mm | v: 35°

03 L.S. 3-Cent. Emily OTS to Jason Leaving
Jason turns to leave.

JASON - Sorry to disturb you and "what's-his-name".

h: 3' 9" | f/l: 32.9mm | v: 35°

04 M.C.U. 18-Rt. Emily seated at sofa
EMILY -There is no "what's-his-name". You come here to gloat?

h: 4' 8" | f/l: 24.2mm | v: 47°

05 M.C.U. 4-Cent. Jason at door
JASON - Why would I do that?

h: 4' 9" | f/l: 71.7mm | v: 17°

06 M.C.U. 19-Rt. Emily seated at sofa
EMILY - I once said I'd dance on your grave.

h: 4' 8" | f/l: 24.2mm | v: 47°

07 L.S. 20-Rt. Jason OTS to Emily
JASON - The Irish jig, right?

EMILY - Twenty years of my life I wasted with you.

h: 6' 3" | f/l: 30.7mm | v: 38°

08 L.S. 5-Cent. Emily OTS to Jason
JASON - It wasn't all a waste. Some of it had to be good.

h: 3' 9" | f/l: 32.9mm | v: 35°

09 L.S. 21-Rt. Jason OTS to Emily
EMILY - It's hard to remember.

h: 6' 3" | f/l: 30.7mm | v: 38°

Simple Storyboard made with Frame Forge

Chapter 5 - Lighting

Lighting used correctly in a scene can bring out more visual drama or draw attention to one particular subject. Good lighting often allows the actors faces to look better than with ambient lighting. Artificial lighting controls aspects like intensity, shadows and facial color, and is used primarily for these reasons. Of course, lighting costs money. This being a budget film makers guide, we will try to help you get the most out of ambient lighting, or obtain the most out of simple artificial lighting techniques using inexpensive lights.

The direction of the light is often more important than the intensity of light. Sunlight falling from a noon sky is more than sufficient in quantity of light. But the quality of light is often poor because it creates harsh shadows on faces. A bright, overcast day is the most favorable condition you can achieve for an outdoor scene. But you can't count on that, and even of you're lucky enough to get it, it might not last long enough to shoot your entire scene.

Some film makers will feel the natural, harsh and changing outdoor lighting gives a realistic look to the scene, and as long as the shots transition well with the lighting, that's OK. You would not the end of one shot to end in sunlight, while the turn around shot begins in overcast.

Budget film often makes use of silver or white reflectors to beam the sunlight from a high angle and reflect it to a low angle on the face, filling in the shadows. The amount of artificial light needed to light the scene with enough light to overcome the shadows of sunlight would exceed the budget of all but Hollywood film makers. An inexpensive reflector can be made by covering a cardboard sheet with aluminum foil. Crinkling the foil first will diffuse the light, helping to create a less intense but more even reflective lighting. An old white bed sheet over a cardboard sheet will provide softer light.

In the studio, or inside an interior room, you may have enough light from a window. Here again, you'll want to control shadows by using additional lighting, and maybe even shading off some of the window light.

Translucent yellow, orange or blue plastic sheeting, called **scrims**, are often used to soften the incoming window light or change the color of light entering the room to match that of the interior lights.

Modern LED panel lights are becoming more popular with budget film makers because of their low cost for entry level models, and their low power use. Often, small internal batteries can provide hours of lighting using LED panels.

Diffusion boxes can be installed on light fixtures to soften the light and bring smoothness to skin tones.

In a pinch, or on a restricted budget, you can bring a standard room lamp closer to the subject to add more light.

You'll typically want to use some direct light to the front of the face, but not too much. This is called the **fill lighting**. You may want to have some light behind the subject to bring out hair features, but again, not too much. This is called **back lighting**. Side lighting can be added to illuminate one side of the face more than the other, bringing

contrast to the face. This is called **key lighting**. Proper and creative lighting can set the mood for the scene, and with a good monitor, you can see the results before you begin to shoot.

The color of light is also important to consider. The color of lighting is important to the camera, because unlike the human eye, it can not adapt as easily to different colored light sources used at the same time.

Ideally, you want your light source to appear as white light to the camera, allowing the natural colors of faces and objects to come through looking normal. This is done through balanced lighting, and also through a camera adjustment called **white balance**. We will discuss that camera feature in detail during the next chapter.

The color of light is measured using the **Kelvin** temperature scale. 2700 degrees Kelvin, expressed as 2700K, is the typical color balance of a typical incandescent bulb such as one you'd find in most homes. It is seen by your eyes as a soft, yellow glow. By matching the color balance setting on the camera to that of the light source, the

camera will see the light source as pure white. In doing so, all the other colors in the image will look correct.

3200K is the color temperature of stage lighting. This looks a bit more whitish, even though it is still within the yellow spectrum.

Fluorescent lights range somewhere within the 4000K area and vary quite widely between brands. Most are perceived as greenish in tint.

Outdoor sunlight is at noon is close to 5600K although it varies by season, time of day, and weather conditions. 5600K is considered the standard for pure white light.

Cloudy conditions range near 6000K, and shady conditions can go to 8000K, depending upon how much blue sky is creating the light in your scene. These color temperatures are in the blue light region.

One of the good things about LED lighting panels is that some models can emulate variable color temperatures depending upon the unit selected. Some are fixed at 2700K, 3200K or 5600K. You can mix them with

other light sources of the same color temperature. Higher priced models have both 2700K and 5600K bulbs with a dimmer that can vary the intensity between the two colors to emulate any color temperature between 2700K and 5600K.

As you can see, lighting encompasses many variables both indoors and out, with a variety if fixtures to accommodate any situation. Lighting is an art form in itself. Practice and experience will bring the best lighting to a scene.

When using high powered incandescent lighting, tremendous heat can build up around the fixture. You'll want to be certain that any colored scrims are rated for high temperature, and are provided with enough space from the bulb to allow adequate convective air cooling. You'll need to turn these lights on only when filming, and secure them for safety so they don't fall on anyone or anything flammable.

Chapter 6 – The Camera

Learning your camera

The camera is your primary tool for capturing your film onto a tangible medium. As such, we will devote much time to its functions and how best to apply them toward creating your film.

This chapter concentrates on informing the reader about the key functions of the camera, what they do, and how to use them to obtain the best looking images possible.

Cameras come in such a wide variety of styles, prices and functions, that it would be impossible to include every camera and every function in this book. You will have to use your camera instruction manual and your brain to locate where the buttons and menu selections are located on your particular camera.

Even when you master the functions of your own camera, knowing how it works is only

one aspect toward obtaining great images. Artistic composition, lighting and editing are all just as important. The finished film is only as good as the weakest link. After learning the techniques in this book, you'll need to practice and experiment in order to master the art of film making.

One of the most important thing any film maker can possess is knowledge. A good smart phone camera in the hands of someone who knows what they are doing can often yield a better film than a good camera in the hands of someone without proper camera skills.

While it is true that better cameras create better images and allow more functional control, many decent films have been created using nothing more than a smart phone. Just look on YouTube if you doubt this. Once you learn the functions of your camera and can adapt its limitations to provide the best images possible, you'll discover some pretty decent scenes can be captured with cameras costing well under a thousand dollars.

While an inexpensive camera can be used to

shoot your film, it is wise to buy the most camera you can afford. Because a good camera in well practiced hands can yield spectacular results.

Current consumer camcorders are mostly **high definition** and fully automatic. You can charge the battery, turn on the camera, aim it, press the record button and shoot a video. Yes, you'll get a recording, but not necessarily the best looking image. Knowledge of lighting and camera functions often trump camera quality when it comes to creating a good film.

DSLR cameras were designed primarily to capture still images. Only recently did they come up with fast enough electronics to create high definition video. Since the primary function of DSLR cameras is the shoot still images, the lenses are also designed for still image use. When used for video, DSLR lenses are often sluggish on focusing and zooming, either automatically or manually.

With a DSLR, in order to limit using the focus adjustment, most shots are composed with the actor maintaining the same distance from

the lens throughout each scene. This is done so the camera operator does not need to change focus during the shot. A true camera is more desirable because it's easier to operate and focus on the fly.

A limitation of DSLR cameras is a time limit imposed on video shots. For tax reasons in Japan, DSLR cameras are limited to shooting only 30 minutes of video at a time. This isn't a problem for movies with short scenes. But it can be a problem for shooting long speeches and presentations.

To create artistic moving imagery, you need to fully understand all the functions of your camera. You'll need to learn how to adjust each camera setting to obtain the look you desire, and you'll need to learn how different settings interact with each other. While camcorder models differ in their features and the control of those features, most of the basic functions are common from one model to another.

The big buzzword in video cameras today is **4K**. This term describes a newer digital video format with improved resolution over **HD** video, or High Definition video recording.

More than likely, if you're just starting out, you'll be shooting HD video. By the way, HD video is often referred to as **2K** video.

HD video is 1920 pixels wide and 1080 pixels high. 4K video is 3840 pixels wide and 2160 pixels high. That's twice the pixels in each direction. This means 4K video has four times as many pixels as HD video. More about this later.

Even though 4K is sharper than HD, it's more expensive to buy a 4K camera. More than that, 4K requires four times the computer horsepower and significantly greater amounts of data storage than HD video. 4K video can require more data rate than some home computers can handle.

Since so much more computer power and data storage is needed, editing 4K video is technically challenging, even for some professionals. Yes, 4K has advantages, but not within the scope of the low budgets of some beginning film makers.

Another challenge with 4K video is distribution, especially for a low budget project. There is currently no means of

distributing 4K video to the average user, because there's no user burnable 4K disc recorders. At least not as of this writing. 4K video can be stored as an Mp4 files and can be uploaded to YouTube. Still, most people don't yet have the technical means to see it in 4K.

I have also heard many actors and viewers complain that because 4K video looks so sharp, it shows too many facial flaws. A well shot HD video can more closely emulate the look of film, which is so prized by the majority of film makers.

Some film makers like to shoot in 4K, then edit in HD. By doing so, this allows the editor the ability to zoom into the scene during post production while maintaining the full quality of the finished HD film. It also means the master 4K video can be re-released years from now when 4K is more common and widespread.

Film Verses Video

We use video in making our movies today, even though we still refer to them as films. Some terminology won't die easily.

In order to understand how the video camera works, it helps to understand how film cameras work. Knowing how light is captured on film, you'll be better equipped to emulate the look of film while using your video medium.

Both film and video capture motion by creating a large number of still shots recorded and played back in rapid succession. A characteristic of our eyes called **perseverance of light** allows these still images to appear as a moving image. To see this process in action, look at a bright object, then close your eyes. For a very brief period, you will observe the image retained on your retina. It is this characteristic of human sight that allows the motion picture process to work using a rapid series of still images.

In the early days of film, it was determined that 24 still images per second, or 24 frames

per second, was the minimum rate that could be used to create the appearance of moving pictures with relatively smooth motion. Higher film rates added little more to the smoothness of the motion, but would consume more film and therefore become more expense. In video, increased expense for faster frame rates is no longer much of an issue.

Each frame of film is exposed all at the same time. When the mechanism opens the camera shutter, the light falls upon the top of the frame and the bottom of the frame all at the same time.

Most video image sensors do not record the entire frame at once. The sensor begins by canning the image at the top of the frame and works its way to the bottom. It requires a small amount of time to create one entire frame. During this time period between recording the top of the frame and the bottom finishing up, the image being captured may move a bit before the bottom of the frame is recorded. This creates a different look to the motion than film.

Another aspect of film is the **granular**

particles that make up each image. The granular structure of the light gathering particles on the film stock is randomly different for each frame, much like sand laid out on a square tile would never fall exactly the same on another tile. As each frame progresses through the film projector, this random grain pattern masks much of the imperfections of film as it passes through at 24 frames per second. Of course, if you stop the film and observe a single frame, you'll see its grain more readily than when it's in motion.

Video on a TV or computer monitor is typically displayed at 30 frames per second. Synchronizing film speeds of 24 frames per second to play on television screens requires a conversion called a **pulldown** process, whereas the 24 frames per second is stretched out to match the TV monitor at 30 frames per second. This is done by repeating every fourth frame of the film in the fifth frame of the video. Essentially, the films frames are displayed as 1-2-3-4-4, 5-6-7-8-8, and so on. In this manner, the film maintains the correct playback speed even though the frame rate of the video monitor is faster.

The artifacts of this pulldown process give the resulting moving image a characteristic all its own, leading some to attribute this as the 'film' look.

Some video cameras can shoot at 24 frames per second to obtain the same pulldown function as film. However, sometimes this process yields motion artifacts that cause a blurry look to fast moving action. A simple solution to this is to shoot the video at 30 frames per second so that it exactly matches frame for frame, the ability of the monitor to play it. The result is a cleaner look to moving images, while still retaining most of the film look of a low frame rate.

Camcorder Components

All video cameras, whether it's the one in your smart phone or the quarter million dollar network TV camera, have several common features. They all have a lens and an image sensor, along with some means of allowing these devices to be controlled so that the image is properly exposed.

A camcorder consists of three major components. The **lens** captures and focuses the light of the subject onto the imaging **sensor** (the "cam").

The resulting frames are stored on the **recording device** (the "corder"), which in the past was a videotape, but is now mostly a digital card or hard drive. Each function is equally important, and the system as a whole is only as good as its weakest link.

While fit, feel and function play a role of personal preference in camcorder selection, it's hard today to find a brand name digital camcorder that is lousy. Almost any brand name digital camcorder in the 500 to 1000 dollar range will work well for creating short films.

Prosumer camcorder models in the 2000 to 4000 dollar range offer better images and more manual control. If you are at this level, you likely already know most of what's in this chapter.

There is debate on whether camcorders with removable lenses are required. While allowing greater flexibility, the result is often a more costly camera, expensive lenses, as well as time consuming on set to change the lens for each scene.

Many cameras offer fixed mounted lenses more than capable of providing clear images and flexible zoom ratios. The speed and convenience of not having to change lenses on the go is often the reason such cameras are chosen.

Lens Types

We mention much about lenses because the lens is one of the two most critical components of the camera. If you are buying a camera to make films, you should find one with a good lens, especially if the lens isn't removable. If I didn't point out all the lens features and imperfections in the sections that follow, you might not notice them until after you made your purchase.

Lenses come in several varieties, but the two main types are called **prime** lenses and **zoom** lenses.

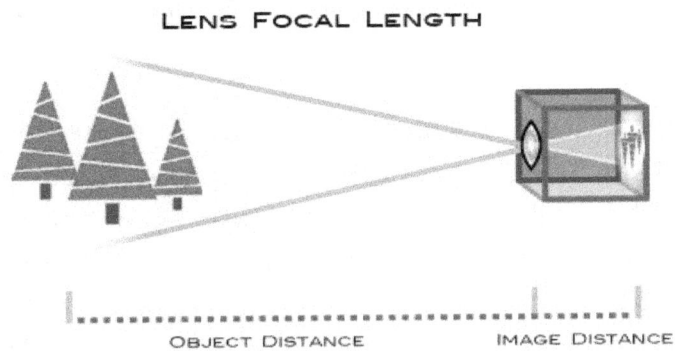

LENS FOCAL LENGTH

OBJECT DISTANCE IMAGE DISTANCE

A **prime lens** has a single **focal length**.

Focal length is the distance from the lens to the image sensor at the point where the image is in focus. The unit of measurement is usually expressed in millimeters, abbreviated as mm.

A wide angle lens might be 16mm, while a telephoto could be 135mm or more. The greater the focal length in millimeters, the larger the image produced on the sensor.

With a **prime lens**, the focal length can not be changed. The only way to change how close a subject shows up in the frame is to physically move the camera closer to, or farther from, the subject. If this isn't sufficient, then the prime lens must be swapped out with one of a different focal length.

Prime lenses produce images that are most often sharper, brighter and less distorted than zoom lenses in the same price range. This is because the internal glass **elements** of the prime lens are fixed in place and don't move, so they can be optimized for one focal length.

High end film makers prefer prime lenses for

their better image quality. Since zooming during a shot is often considered an amateur move, camera operators will bring several prime lenses to a shoot and change them as needed for each shot. Most cameras that use prime lenses have removable lenses. One example of a camera with a non removable prime lens is your smart phone. Very few specialty video cameras like the GoPro are made with prime lenses.

Zoom lenses use a mechanical means of moving the glass elements inside the lens barrel in order to obtain variable focal lengths with one lens.

In a zoom lens, the focal length is expressed as the nearest and farthest the lens can obtain. A typical example of a zoom lens is the kit lens that comes with many DSLR cameras. It's usually in the range of 18 to 55 millimeters, expressed as an 18x55 lens.

You might also hear a a zoom lens expressed in a range from shortest to longest focal length, say, a 3x zoom or a 10x zoom. That's simply the mathematical reference between the least and most amount the lens can zoom. For example, a

10x lens might range from 15mm wide angle to 150mm zoom, or perhaps from 8mm to 80mm.

Because a zoom lens is more complex from a mechanical standpoint, and the lens elements must be shaped to work at different distances from each other, there are design compromises that sacrifice some sharpness and other image distortions.

Newer zoom lenses can come close to providing the image quality of prime lenses. The difference in quality can be hard to see for most viewers.

Some high end cameras that have fixed zoom lenses employ built in electronic circuits to minimize any mechanical lens distortions.

One zoom technique used with inexpensive cameras such as a smart phone is called **digital zoom**. This method of zooming does not move the lens elements. It electronically enlarges the apparent image on the sensor. In doing so, the pixels of the sensor are also electronically enlarged, giving a grainy and pixelated look to the image when it is

zoomed in.

Digital zoom is more of a marketing tool than it is useful. If your camcorder has digital or electronic zoom, you should turn it off in the menu. If that isn't possible, avoid using it altogether.

In order to retain full image quality, use only the optical zoom, which is the actual zoom produced by mechanically moving the lens elements themselves.

Focus

The job of the lens is to **focus** the the light from your scene onto the camera sensor as an image, with as much clarity as possible.

Focus is achieved automatically in some cameras. Electronic circuits can sense the edges or the contrast of the images and move the lens in and out until the edges are as sharp as possible. This process takes some time. It can also be fooled by an object closer to the camera than the main subject. Moving the camera slightly can cause the

lens to focus first on one object, then another, creating a hunt and peck for the focus of what *it* thinks should be the main subject.

Better cameras allow the operator to switch to manual focus mode so the *operator* can choose the subject on which to focus. This, of course, means the operator will have to manually readjust the focus smoothly as the subject, likely an actor, moves closer or farther from the camera. It is for this reason we mentioned a few chapters ago that actors must learn to hold their position in certain shots so that they stay in proper focus.

Not all lenses focus in the same manner. Expensive lenses, as well as those that were manufactured prior to electronic focus, will use mechanical metal rings to move the internal lens elements. When the operator moves the ring, the lens moves proportionally. With mechanical focus, the operator has almost a full turn of the ring from close focus to far. In time, the operator can remember the position of the ring and focus accurately without even looking in the viewfinder.

When automatic focus was invented, a motorized electronically controlled means was implemented to move the lens elements. This means that when the operator turns the ring, they are driving a motor which focuses the lens. This indirect means of controlling focus is harder to feel, and all but impossible to predict. It also isn't consistent, meaning some lens rings will turn several rotations fro near to far, and others will only move a quarter turn or less from near to far. This makes focusing either too slow to respond to changing conditions, or too rapid to get it right the first time.

Even worse is the focus control that has no rings at all, but simply uses two push buttons. This makes crisp manual focus nearly impossible.

Lens Apertures and F-Stops

The next function a lens performs is controlling the amount of light that passes through it. This is done by use of an internal mechanical device called an **iris**. This is sometimes referred to as an an **aperture**. Although the two words are often used interchangeably, they are different. The iris is the actual mechanical device, whereas the aperture is the term used to refer to the open hole. A wide aperture, or large aperture, is a larger hole and allows more light to pass through the lens. The size of the aperture is controlled by the iris.

Stylized 'Iris diaphragm' from a camera

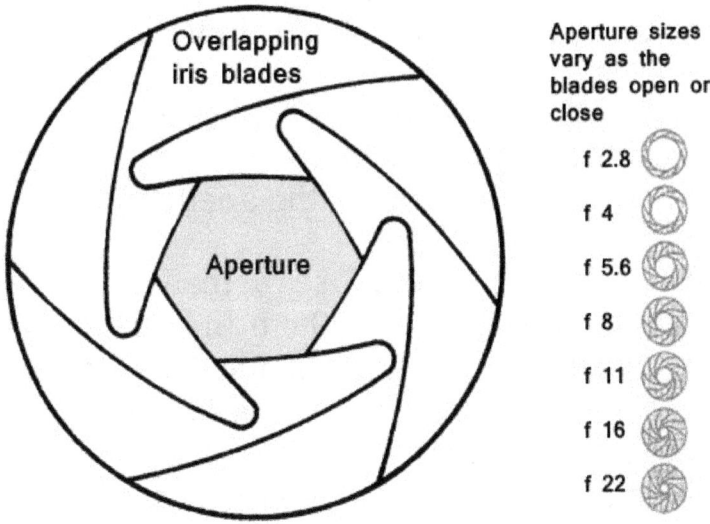

The iris is a series of movable curved blades that form a nearly circular hole that can be varied in size. This re-sizable hole controls the amount of light that passes through the lens. The bigger the hole is, the larger the aperture is said to be. A larger aperture lets in more light.

The aperture is measured in a unit called an **F-Stop**. F-Stops range typically from F1.4 to F32, with the smaller number referring to the larger aperture. So an F2.8 aperture would

allow more light to pass than say, an F22 aperture. This is because F2.8 is actually a shorter way of describing the true meaning of the term, which is a fraction, 1 over 2.8.

The number of the F-Stop refers to the relationship between the focal length of the lens and the diameter of the aperture.

To explain this, let's use a mathematically easy focal length of 100mm (millimeters). If the maximum aperture of the lens itself is 50mm in diameter, then we divide 100 by 50 and come up with 2. Such a lens is said to be an F2 lens, because the ratio between the maximum aperture (50mm) and the focal length (100mm) is 1 over 2, expressed more simply as F2.

At F4, that same 100mm lens would have a maximum aperture of 25mm, or 1 over 4. Because we leave out the fraction part of the equation for simplicity sake, the smaller the F-Stop number, the wider the aperture, and the more light it will allow to pass.

The smaller number the F-Stop is, the more expensive the lens will be. Cost compromises are often made, and many

lenses have a maximum F-Stop of F2.8, F3.5 or even F5.6.

Making it more difficult to follow, the maximum F-Stop of a lens will not always be the same at the long end of the zoom.

A maximum 50mm aperture of F2 on the 100mm lens will become F4 when the lens zooms out to 200mm. That's because the 50mm aperture is now only ¼, or 1 over 4, the relationship of 200mm.

In order to have a 200mm lens that is an F2 lens, the aperture would have to be 100mm. This extra diameter means the lens would also be bigger around, which translates to costing a great deal more.

It should be noted that the F-Stops are typically numbered as they are to allow each graduation to reduce the amount of light passing through the lens light by one half.

The common F-Stop detente settings are F1.4, F2, F2.8, F4, F5.6, F8, F11, F16, F22 and F32. Some lenses, of course, can provide variable F-Stops in between those.

All other camera factors being equal, the lower F-Stop numbers will let in more light. But another factor controlled by the F-Stop is called **depth of field**. Depth of field is a zone between the camera and the subject where the subject remains in sharp focus. This depth of field varies in minimum and maximum distance depending upon the F-Stop of the aperture and the focal length of the lens.

If the aperture is set to F22 on the minimum focal length of a zoom lens, say the 10-100mm lens of our example, then everything from three feet to infinity would remain in sharp focus. We would refer to it as being a wide depth of field when everything in the frame remains in focus. This would be good, say, for a roving camera depicting the view of someone walking through the scene.

A wide depth of field is unflattering to a close up shot of one person, because the person blends in to the sharply focused background. With our manual settings, we can change this. By increasing the zoom to 50mm and moving five times further from the subject, we begin to see the background come out of focus while the person is sharp in the

viewfinder. We can make the background even less focused, or softer, by increasing the aperture to a smaller F-Stop, say F2.8. Now, the subject looks very clear against a soft, unfocused background.

When the F-Stop and focal length are set to provide the soft focus in the background, this is stated as having a shallow depth of field. The clear focus zone may now be limited to say, between eight and ten feet from the camera. Anything closer than eight feet or farther than ten feet will become increasingly out of focus the farther from these distances we move away.

Naturally, as we change the F-Stop and focal length to obtain the desired depth of field, we are also changing how much light enters the lens. We must compensate for that difference somehow, or the image may become **overexposed** or **underexposed**.

We can change the **exposure** by providing more or less light upon the subject and/or the background. Exposure is also controlled by changing other camera settings. Two of these settings are called **shutter speed** and video **gain**.

Shutter speed is a setting that controls how much time during each frame that the lens is allowed to pass light to the sensor.

Shutter speed is measured in fractions of a second and again, often expressed as a whole number rather than the fraction that it is. For instance, a shutter speed of $1/60^{th}$ of a second would simply be expressed as 60.

When you increase the shutter speed to higher numbers like 250 or 500, you begin to see a staccato effect in the motion of objects. This is because less time is allotted to capturing the image, and more time given to a darkened space in between.

It is sometimes confusing referring to frame rates and shutter speeds, because the numbers are similar. A frame rate can be 60 frames a second, and a shutter speed can also be 60. Though the numbers look the same, they are in fact measurements of two completely different things.

Frame rate refers to how many times the shutter opens each second.

Shutter speed refers to how long each

individual frame remains open.

The faster the shutter speed, the less light makes it to the image sensor. The standard shutter speed for video in the USA is 30 frames per second, and in the UK and much of Europe it is 25 frames per second.

If you set the shutter speed lower than the frame rate, you are effectively superimposing multiple frames over each other. This is a method to increase the light exposure beyond the capability of the camera, but the effect is excessive blur from anything in the frame that moves. Sometimes, however, this is an artistic decision that looks pretty cool.

As design would have it, shutter speeds are also set up so that the change from one to the other is one half the amount of light or double the amount of light (in the other direction) passing through the lens. This means changing the shutter speed one notch low and changing the F-Stop one notch high, the light exposure remains the same.

As an example, let's say we were filming an outdoor scene at F11 and shutter speed 60 with a perfect exposure. If we wanted to

create less depth of field softening the background focus, we would change the aperture to F8 and the shutter speed to 120. The remaining exposure would be the same. This works for each increment up or down until one of them reaches the camera's limit.

The standard increments for shutter speed are expressed as 8 (for $1/8^{th}$ of a second), 15, 30, 60, 120, 250, 500 and 1000. Some models go higher or lower, and some can be set in between.

Video gain is a measurement of how much the camera's electronics can amplify the signal to make the image look brighter. In film cameras, this was expressed as film speed **ISO**. Some video cameras still use the term ISO so that film long time film cinematographers can operate within their established comfort zone.

Video gain is measured in decibels of amplification, expressed as **dB**. The standard minimum amount of amplification is termed as **0dB**. Every three dB is double the amplification, so cameras are set up in dB increments of three (+3, +6, +9, etc.). Some cameras go up to +18db gain, while others

go as high as +36db.

The higher the amount of gain, the more grain appears in the image. At some point, the grain becomes objectionable. Or it might be added on purpose for artistic reasons.

Remember that relationship of half and double for F-Stops and shutter speeds? Video gain is set up the same way, so increasing gain one notch and lowering one notch on either shutter speed or aperture, results in the same overall light exposure.

As we can see, changing one camera setting often must be offset by setting another. The resulting manual settings can be overwhelming to a beginner, but it is always better to maintain control yourself as opposed to allowing the camera to automatically control all the settings.

The automatic settings on the camera can not make artistic judgments, especially when the subject being recorded is not evenly lit. The camera will simply average everything out for an overall exposure. But the subject may be too dark against a brightly lit background, and the camera won't know this.

An example of this would be a person in a dimly lit room sitting in front of a day lit window. The camera simply adjusts for what mostly fills the screen, which would be the brightly lit window. The person, most likely the important subject, would appear too dark compared to the bright window.

To correct this, some camcorders offer a back light compensation setting. This is an average setting, and while it may improve the lighting on the subject, it isn't perfect.

Advanced cameras allow the user to manually control one setting while allowing the camera to control the others automatically.

Even more advanced cameras will allow pre-determined automatic limits on some settings, so the video gain, say, can automatically vary between 0dB and 9dB. This way, you, the artist, can set the exposure the way you want.

Although it might seem repetitive, we will explore some of these settings in upcoming pages, simply because some readers might better understand these subjects when

explained from a slightly different point of view.

Lens Distortions

All lenses are not created equal. From strictly a mechanical respect, some lenses are cheap and imprecise. Some cheap zoom lenses will not maintain sharp focus throughout the zoom range, and must be refocused each time the zoom is changed. The ability to maintain correct focus throughout the entire zoom range is called **back focus**. High end lenses have adjustments for this, but most lenses you'll encounter will not.

A good zoom lens will feel smooth and precise, and will maintain clear focus throughout the entire range of zoom.

Better zoom lenses with a wide range of zoom can be sharp enough to satisfy all but the most discriminating camera operators, negating the need for removable lenses. Most professional TV cameras and well made video cameras have such well made

zoom lenses, which is why they are costly. TV and news crews require faster scene setup times. For the sake of getting timely shots, they do not want their lenses to be removed.

Aside from deviations in lens mechanics, the actual quality of the image is also subject to a few types of lens imperfections.

The image sensor behind the lens is flat. It should be easy to envision that the distance from the lens to the middle of the sensor is shorter then the distance from the the lens to the edges of the sensor. The lens has to be designed to compensate for these changes in distance so that the image stays in focus on the entire sensor at the same time. This is done by using multiple elements within the lens.

If you have ever seen a simple magnifying glass, such instrument is considered a single element lens. Multiple glass elements in the camera lens barrel will compensate for some of the distortions a lens might have, but nothing in life is perfect.

The types of distortions you will see in many

lenses are geometric distortion, chromatic aberration, lens flaring and poor focus at the corners of the image. The amount of distortion will vary according to lens quality, and every lens has some amount of distortion. The goal is to bring the level of distortion to a point so low as to be imperceptible by even a discriminating eye.

Geometric distortion is easy to spot. Look at the doorways or other straight objects in the sides and corners of the frame. See if they tend to remain straight up and down. Typically, as the lens closes in on wide angle, the straight lines of the doorway will begin to tilt or even bow inward or outward. This is the sign of a lens that isn't well corrected for geometric distortion.

Chromatic aberration is seen as colored fringes around the edges of objects. The best scene for showing this is to shoot bare tree branches against a bright sky. The closer you get to the edges of the frame, you'll start to see slight color fringing around the tree branches if the lens isn't made well. Cheaper lenses have more color fringing.

Lens flare occurs when bright light enters

the lens, reflects off one element and is directed into the other elements. Special coatings on the elements can reduce the flaring, but not entirely eliminate it. In order to eliminate flaring, you must re-position the light source. In the case of the sun as your light source, you must reorient the position of the camera or wait for the sun to move through the sky. OK, to be astronomically correct, you'll wait for the earth to rotate.

Still another distortion is seen mainly in cheap lenses. The focus in one corner may be fuzzy while the focus on the other side of the frame is clear, even when both objects are the same distance away. This is caused by a lens element that is not mounted perfectly inside the lens barrel. One element is slightly tilted, causing one side of the image to look out of focus.

Worst of all is a lens that simply looks fuzzy around all the edges of the subject, especially when zoomed in. This is the result of lens elements that are not properly matched, or elements that are not properly ground down to a perfect spherical curve. You'll sometimes see this mainly in cheap camcorders at full zoom. If the lens can't be

replaced, the problem can't be fixed. You'll simply have to forego using such lens at maximum zoom.

It is becoming more common for camera makers to incorporate electronics into the camera that can correct lens imperfections. These can be corrected to the point where the user sees what looks like a perfect image corner to corner. This usually only works with one particular lens, so it is more widely used with permanently mounted zoom lenses.

The Image Sensor

The next most important part of your camera, and a major factor in providing a quality image, is the **image sensor**. It is here where the focused image from the lens is magically turned into the digital signal that will eventually become your movie.

The image sensor is responsible for aspects of your image such as color reproduction, resolution, shutter speed, depth of field and light sensitivity.

Image sensors are manufactured in all sizes and qualities. Generally, any recently made, name brand camera will have a sufficient quality image sensor to capture images good enough to make your movie. In fact, many films have been made with inexpensive DSLR cameras and even smart phones. They're all over YouTube.

You probably know the term **megapixel** is used to describe the camera's image sensor. A megapixel is one million pixels. Most modern cameras have 20 megapixels or more. Most of those pixels are used for capturing still images. We don't need all of

those millions of pixels for video.

Driven by camera marketing hype, most users mistakenly equate only the amount of pixels to judge image quality. Nothing could be farther from the truth. Other factors play a greater role in determining image quality besides how many pixels are on the sensor. This is especially true for video, where the amount of pixels needed to create **HD video** quality is only two megapixels. No, this isn't a misprint. It's two megapixels.

HD (High Definition) video frames are 1920 pixels wide by 1080 pixels high. Simple math. 1920 times 1080 is just a tad over two million. (2 megapixels).

4K video is comprised of frames that are 3840 by 2160 pixels, or a little more than eight million pixels (8 megapixels). Using more than this is superfluous for video. In fact, some manufacturers are marketing cameras with less megapixels, because less but larger pixels create brighter and cleaner video.

There are two types of image sensor chips; **CMOS** and **CCD**.

CMOS (Complimentary Metal Oxide Semiconductor) image sensors record the image in a series of scanned lines of pixels across the sensor, beginning from top to bottom. Because of this scanning activity, any motion in your scene that begins to get recorded at the top of the frame will progress somewhat before the rest of the scene is recorded at the bottom of the frame. This causes an effect called **rolling shutter**, and manifests itself as making objects appear to look slanted when the camera or the subject moves too rapidly.

The other type of sensor is called a **CCD**, for Charge Coupled Device. CCD sensors capture the entire frame at once, allowing the video motion to appear more like film. CCD sensors are also called global shutters, since they capture an entire frame at once. Naturally, they cost more than MOS sensors, not so much for the sensor itself, but for the electronics needed to store the entire frame information at once.

One of the biggest differences between image sensors is their size. The smallest I have seen are one-sixth of an inch diagonally. The largest (at least for most

video cameras) measure nearly two inches across, and are called full frame. They measure 24 x 36 millimeters; the same size as full frame 35mm film images. There are sizes in between, of course, and some industrial and NASA cameras have larger sensors. But you won't be using those.

All other things being equal, a larger image sensor provides a cleaner and brighter image with a more shallow depth of field. A downside of larger sensors is that lenses for them must be bigger, and therefore more expensive.

It should be noted that the size of the sensor does not correlate with the amount of pixels. Tiny 1/5 inch sensors can have 20 megapixels, and full frame 24 x 36 mm sensors can have 12 megapixels. The larger sensor, even with less pixels, would produce a better video image.

Some common sizes for image sensors are 1/6 inch, ¼ inch, 1/3 inch, 1/2 inch, one inch, and Four Thirds (an inch and a third). Other sizes are called by name. Super 35, APS and Full Frame. Full Frame is 24 by 36 millimeters, and is popular in the higher end

DSLR cameras for its shallow depth of field.

Sometimes shallow depth of field can be too much of a good thing. The depth of field can be so shallow that in the closeup of a face, the eyes might be in focus while at the same time, the nose is out of focus. It's very difficult to obtain image sharpness on the entire face at once during extreme closeups.

Not too many years ago, cameras with a single chip were considered only amateur cameras. This is because back then, a single chip could not capture the full, accurate colors of an image. At the time, high end cameras used three image sensors – one for green, one for red and one for blue.

With a three chip camera, the light passing through the lens is split into three beams by a glass prism. Each beam of light strikes a different color sensitive sensor. The sensors are aligned so that the combination of the three color signals will all line up exactly in the correct positions and produce a richly saturated, accurate color image. Since each chip and its related electronics only have to work with a single color, they create much more pure color than a single chip camera.

Three-chip cameras, as they are called, use smaller chips ranging in size from one fifth of an inch, up to two thirds of an inch. Larger chips are impractical in three chip cameras. Three chip cameras are used mostly in the television industry, where color accuracy is important, and users desire the wider depth of field so more of the scene remains in focus.

Sensors and their associated electronics have come a long way in the last few years. The number of pixels are now so great, the color images provided by a single, large chip finally equals that produced by the three chip cameras.

More importantly, the electronic circuits that amplify the signals from the image sensor have become much better. Amplification of the signal also increases the amplification of video noise, seen as a grainy overlay on the image.

Better electronics have made it possible to shoot clean looking images under moonlight, but at press time, these cameras are still 30,000 dollars. The technology is slowly working its way into consumer cameras with

cleaner images in low room lighting now quite common.

It is the characteristics and higher quality of the electronics, more than the image sensor, that create a cleaner looking image with less visual artifacts. That's why simply judging an image sensor only by its megapixels isn't an accurate assessment of image quality. No matter how good the marketing material is, it's always your eyes that will tell you which camera best suits your needs.

Aspect Ratio is another factor in image sensor chips. The aspect ratio is the ratio between the width of the image (4) to the height of the image (3). The older TV standard used this aspect ratio of 4 by 3, (4x3). Compared with modern wide screen LCD TVs, 4x3 looks nearly square.

Current HD and 4K televisions have a wide screen aspect ratio of 16x9. This makes TV look more theater-like. This is a wide screen image compared to the older TVs.

Bear in mind that these numbers, 4x3, and 16x9, are not absolute size measurements, but simply ratios between image width and

height.

Some image sensors still use the 4x3 aspect ratio. This means that in order to shoot 16x9 wide screen video, the 4x3 sensor does not use some of its pixels in the upper and lower parts of the frame.

Newer cameras have chips that are native to the proportions of 16 by 9 in order to match the 16x9 aspect ratio of LCD televisions.

Frame Rates

Every video camera shoots multiple still frames per second to create what looks to our eyes as a moving image.

As we recall, a popular frame rate for film is 24 frames per second. Many video cameras will also shoot at 24 frames per second, and film makers like this because it helps obtain the look of film.

Television screens, the place where most films are viewed, display video images at a rate of 30 frames per second. This is the TV standard frame rate, and also a popular frame rate for video cameras.

When a film made at 24 frames a second is played on a TV screen at 30 frames a second, a compromise must be made so the resulting film plays at the correct speed. In doing so, every fourth frame must be repeated twice. F1, F2, F3, F4, F4.

This frame conversion allows 24 frames to fit into the space where 30 need to be shown. The result of such conversion often causes distortion in the motion.

An easy solution to this problem is to record your film at the rate of 30 frames per second. In this manner, you will still obtain the 'film look', but now, each frame is displayed one at a time as it was recorded. This provides more sharpness and more natural motion to the end result.

No doubt you've seen numbers like 24P, 30P, 60P and 60i, but what do they mean?

30P means 30 **frames** per second **Progressive**.

60i means 60 **fields** per second **Interlaced**.

A field is half of a frame, in a manner of speaking, so 60 fields equals 30 frames. Let's clarify this.

In the early days of television, all TV was 60 frames interlaced, represented as 60i. Because of technical limitations of early TV systems, the image was scanned from the top of the frame to bottom with only half the resolution of the whole frame. This half scan is called one field.

Next, the scan would resume from the

bottom of the frame to the top, filling in the missing lines between those previously scanned.

The first scan from top to bottom was field one, and this took 1/60th of a second. The scan from bottom to top was called field two, and this completed the image in an additional 1/60th of a second.

These two fields were interlaced together, forming a single, full video frame every 1/30th of a second. This interlaced scanning method is sometimes used today to remain fully compatible with television production.

Today, modern cameras and TV monitors do not need to use the interlace method. With newer technology, the entire scanning process can now take place in a single frame from top to bottom, yielding a sharper image overall than interlacing can provide. This is why 30P looks sharper than 60i. But 30P gives up the smoothness of motion created by 60i.

60P (60 Frames Progressive) yields the smooth motion of 60i combined with the sharper resolution of 30P.

The only downside to 60P is the resulting data file is twice the size as 60i or 30P. That means it takes up double the storage space on a hard drive, and requires double the processing power in the computer to do the editing. With faster computers and cheaper memory storage, this data issue is becoming less of a problem.

In summary, you'll do well to capture the film look, sharpness, system compatibly, and file efficiency, if you use the 30P frame rate to master your film project.

Some higher end cameras can record at frame rates of 120, 240 or higher frame rates. These fast frame rates are used only for creating smooth, slow motion video.

If you record a video at 120 frames per second and play it back at 30 frames per second, you create slow motion at ¼ the speed of the original action. This is often done in post production.

Recording Quality

Almost all cameras have a means of selecting the recording quality. In any modern camera that records a digital signal onto a memory card, the recording quality setting changes the **data rate** of the recording.

If every bit of the video signal was recorded exactly as it was fed by the image sensor into the electronics, the data rate would be so high that almost nothing could play back the video. In addition, the file size of the recording would be so large that a memory card will fill up after only a few minutes of video.

In order to make digital video recording practical for the everyday film maker, engineers devised a way to compress the video signal significantly. These compression methods differ, and each type of compression scheme causes some degradation of the image.

Higher data rates of recorded video will not determine image sharpness as much as they will reduce the visible blocks of pixels that

create the image. In order to save space on the storage medium, images are compressed into smaller data rates by bundling the pixels in blocks of 8x8 pixels. The efficiency of this process falls apart when the data rate is low and scene motion is high.

A smaller data rate allows more video to fit on a memory card, but the trade off is less image quality. Loss of quality is most often seen in faster moving images than relatively still images like head shots. This is because of how compression works.

Slow data rates are acceptable for images with little motion, such as a person behind a podium giving a speech. High data rates are needed to accurately reproduce the high motion of a sporting event or action scene.

Data rates are expressed as megabits per second, often abbreviated as MPS. Six megabits per second is the maximum FCC allotted bandwidth for TV broadcast signals, so sometimes high motion TV shows end up looking blocky. This is known as digital artifacting.

Your camera can record at higher data rates

than TV broadcasting. Typically, 17 megabits per second is the minimum data rate that can mask most digital artifacting.

Higher data rates don't add proportional amounts of increased resolution. This means 10 MPS is not twice as sharp as 5 MPS. Sharpness does appear a bit better, but what really improves is the lack of digital motion artifacts, which are seen as a breaking up of the image into tiny blocks during high motion scenes, and a shimmering effect around small, sharp patterns such as tree branches or intricate clothing designs.

Only a few years ago, data rates in consumer cameras topped out at 24 megabits per second. Today, 100 megabits per second is the high limit for 4K video, and 50 megabits per second is the high limit for 2K video. Movie industry cameras can go much higher.

Without getting overly technical, here are the two main compression techniques used in video cameras today. One creates an **MOV** type file, and the other creates an **MTS** type file. You may also see these files referred to as **AVCHD** files.

MOV files are used mainly by Apple computers, and by Nikon and Canon cameras.

MTS files are created by Sony and Panasonic cameras. These are most easily compatible with PC computers.

A process known as transcoding can adapt either file to work with either computer system. Transcoding takes time to process, and also adds a small amount of loss to the image quality. It's often necessary to transcode files if have a camcorder that records one type of file and an editing computer that uses another.

Digital compression is performed by complex computer calculations between the visual changes in frames. What this process does is to compare the last frame to the present frame, look for differences between the two frames, and only record the differences. The remainder of the image that is the same between the two frames remains unchanged. In this manner, we can vastly reduce digital storage needs, and fit much more video onto a card or hard drive. This is how MOV files and older MPG files compress images.

The MTS compression scheme goes a step further by comparing the image changes between the **previous** 15 frames. This allows each frame of video to be more efficiently compressed while retaining higher image quality.

MTS files can be 1/7th the size of MOV files while retaining the same level of image quality. The trade off is that MTS files require a higher horsepower computer to play smoothly. This was a problem years ago, but most modern computers can play MTS files without stuttering.

It should be known that during the transcoding process from MTS to MOV, your resulting video files can consume seven times the hard drive space of the original MTS file.

Some cameras can create MP4 files, which are compatible with almost any computer or playback device. Most 4K files are MP4 files. The final rendering process of a finished video project is almost always saved as an MP4 file so that it can played back on any device.

Users can select the data rate of the rendered MP4 files in the editing software.

The additional types of files available and all their subsets and explanations could easily fill another hundred pages. I've only touched upon the most common files you will come across.

How Is Color Reproduced?

Our eyes have color sensors in our retinas called **cones**. Some cones are sensitive to red light, some are sensitive to green light and some to only blue light. Through the blending of only these three basic colors, **red, green** and **blue**, our eyes can perceive an infinite amount of different colors.

Cameras work on a similar principle. Just as our eyes recreate millions of colors from red, green and blue cones, electronic image sensors do the same thing using millions of tiny light-sensitive electronic receptors called **pixels**, some sensitive to each of the three basic red, green and blue colors.

In order to provide seamless color graduations in images, 24 data bits per pixel are used to represent the possible 16.7 million colors.

8 bits are used for the red pixels, 8 for green and 8 for blue. I tell you this not to confuse you with math, but simply so you'll know what it means when you see the terms, 8 bit and 24 bit color.

Some of you may remember the old computer screens where a blue sky had bands of blue and wasn't smooth. This is because early computers used 16, or even 8 bit color, and could not create enough shades of blue to appear seamless.

Naturally, some expensive cameras use more color bits, but they aren't likely to be in the price range of a student film maker.

Depth of Field

One aspect that makes movies mastered on 35mm film desirable is something called **depth of field**.

You can see this on close up shots where the actor's face is in sharp focus and the background is very soft, or out of focus. This tends to accentuate the actor from the background, and this is often desirable.

A shot that has the subject in sharp focus against a soft background is said to have a shallow depth of field. We call it that because there's a very shallow range of distance where the subject is in sharp focus. This is also called a soft **bokeh.**

Camcorders with larger image sensors measuring one inch and larger will easily create a shallow depth of field. A camcorder with a tiny image sensor, say under half an inch, will have a high depth of field, or very little bokeh.

A high depth of field allows the entire frame to be in focus, even though the subject is close and the background is far away. This is

desirable for news gathering, where the objective is to keep everything in focus. For this reason, news cameras have smaller image sensors.

Other factors that affect depth of field are the distances between the camera, the subject and the background. The settings of the camera lens also affect depth of field. Often one factor can offset another, but in general, a larger image sensor is always better for a low depth of field, and for other desirable image factors, as well.

The amount of lens zoom also affects depth of field. Generally, the less amount of zoom used, the greater the depth of field. At wide angle, or minimum zoom, everything from three feet to infinity usually remains in focus. This is said to be a maximum depth of field.

If you wanted the subject clear and the background soft, you would increase the zoom and step back from the person to keep their body the same size in the frame while the background focus would soften.

Dynamic Range

A sometimes overlooked, but not overseen, property of video imaging is **dynamic range**. Dynamic range is the difference between the darkest and brightest part of the image that can be clearly seen at the same time without losing detail. In film, the term used was **contrast ratio**. It basically means the same thing as dynamic range.

Dynamic range is measured in F-Stops. Eleven or twelve F-Stops of dynamic range is considered very good, with fourteen being excellent. High dynamic range will allow better cameras to see the face of a dimly lit subject against the background of a bright window, or the detail of both a white shirt and black pants in a sun lit scene. Video wasn't always this way.

With early video cameras, when you'd shoot outdoors, the blue sky would often be washed out and look white. If you adjusted the camera to get the sky blue, the faces would be so dark you couldn't see the detail. That's because early sensors had very poor dynamic range of only five or six F-Stops.

New sensors can see a much wider range between light and dark, but as of yet, no camera can match the wide dynamic range of the human eye. Give it a few more years.

White Balance

Light sources come in a variety of colors from yellowish orange like candle light, to cool blue like the shade of a tree on a sunny day.

The white balance function of the camera is to neutralize the effect of the predominant light source so it appears to the camera as pure white, even if it isn't. Once the white balance is properly set, every object in the scene will appear to the camera as its natural color.

The difference in source light color is called **color temperature**. Our eyes continually adjust for different color temperatures regardless of the light source.

Try this simple experiment to see for yourself how the eye adjusts color balance. For about half a minute, hold the palm of your hand over one eye as you look at a brightly lit scene (never look directly at the sun). Next, move your hand away from your eye. Look at the scene with just your left eye, then just

your right. As you open and close one eye at a time, you will see the colors of what you are looking at appear different between both eyes. This is because you 'fooled' one eye into setting itself for a different color light source (the skin tone of your hand).

Each source of light has a specific **color temperature.** This is measured in a term called '**degrees Kelvin**', expressed as **K**. For instance, the color temperature of the sun at noon is about 5600K. In the shade, color temperature go up to 8000K. Indoor room lights are about 2700K, while stage lighting is a standard 3200K. Candle light might be 2000K.

If your camcorder had only one color temperature setting, then objects outdoors would look too blue, and objects indoors would look too yellow or orange.

Not all cameras can set white balance the same way. Most phone cameras can only set color balance automatically. Better cameras have dedicated buttons for white balance, while smaller cameras will require sifting through the layers of a menu to make that

change.

There are different means of setting white balance. One way is to use the automatic white trace setting. As the light source changes color, the camera automatically adapts. But this setting can be fooled by brightly colored objects that occupy a majority of the frame.

An example would be looking at green grass and green trees. The camera will try to force the green to look 'white', making the rest of the image look too purple. For this reason, many camcorders have manual or preset white balance settings.

Most camera will have three or four presets. Generally, these are 3200K for indoor lights, 4000K for fluorescent light, 5600K for sunlight and 6500K for overcast skies. Some consumer cameras use icons instead of numbers to display these presets.

There are two ways to manually set the white balance. One is to hold a white card in front of the lens. The card will be illuminated by the primary light source for the scene. You aim the camera and zoom in on the white

card, then press a white balance button. It takes a few seconds for the camera to manually adjust to the white balance setting. Now, all colors will look natural.

When white balance is manually set, no matter what color dominates your scene, the white balance setting will not drift to over-correct for that color. Of course, if you move to a different lighting condition, you'll have to reset the manual white balance.

If you aim the camera at a pastel colored object and push the button, you can trick the camera into seeing other colors differently. Aiming at a pastel blue card and setting the white balance will make the entire image look warmer, or a little more yellowish than usual.

Aiming at a pastel yellow card forces the entire image to appear more bluish, or cool. Advanced operators use these techniques in combination with manual exposure to simulate making bright daylight appear as soft moonlight.

More advanced cameras will allow the user to dial in any color temperature, usually in 100K graduations between 2500K and

9500K. In this manner, you can dictate the look of the scene, and dial in a warmer or cooler setting as you watch the color in the viewfinder or monitor. The only thing to mention here is that your viewfinder might not be calibrated to reproduce color the same as your TV monitor. Never allow your camera viewfinder to be your only means of setting your white balance.

In the event you set the white balance a little off, you can make corrections in post production during the edit process. Some beginners fail to properly set white balance in the camera, feeling they can make corrections later in post. While that may be possible, you can't correct every color perfectly if the original white balance isn't at least somewhat close.

In news gathering, where the fast action might not allow you enough time to set up your camera perfectly, you are better off grabbing the shot off color than fiddling with the controls and missing the shot altogether.

ISO and Video Gain

When your camcorder lens iris has opened up all the way to allow as much light through as possible, it might not be enough to get a good exposure in low light. At this point, the electronics in the camcorder will take over.

The camera circuitry will amplify the video signal to make the image look brighter. This amplification is called **Video Gain.** To emulate the familiarity of those who used to work in film, this is also referred to as **ISO**. Most video camcorders will express gain in decibels (**dB**), while most DSLR will still use ISO.

Typically, zero dB (0 dB) of video gain is equivalent to an ISO rating of 100. 18dB of video gain is the equivalent of ISO 3200.

Each 3 dB of gain is twice the exposure. ISO numbers double to represent twice the exposure.

When the video gain (or ISO) reaches it's maximum setting, the resulting image may look grainy with colored specs appearing in

the dark areas of the picture. It may also cause the colors to become more muted or tinted toward an undesirable color.

On advanced camcorders, video gain is expressed in decibels, abbreviated as dB. Typical settings range from zero (0 dB), the least amount of amplification, to plus thirty six (+36 dB), the most amplification. If you are fortunate enough to have full manual control, setting the gain a few stops lower, such as +21 or +18 dB, should reduce the video grain while allowing a reasonably well exposed image. Naturally, the best solution is to add more light and keep the gain setting lower.

Generally, the old expression is more gain equals more grain. Cameras with better electronics and cleaner, larger image sensors will produce less visible grain in the image at high amplification. This is often a more important feature than having a larger number of mega pixels, and it is the reason you should look beyond megapixels as the main descriptor of sensor quality. Camera makers don't always print these additional specs because most consumers would not know what they mean.

On many consumer camcorders, video gain may not be adjustable by manual control. When it is, it may be labeled as "exposure". This is confusing, because the iris uses the same term.

If you can manually set the exposure in a lower priced camcorder, you are usually locking the iris and the gain at the same time. This allows you to set the exposure for an indoor room, then pan past a window without the image temporarily getting too dark as the bright window comes into the frame.

I encourage you to experiment with different manual exposure settings, zoom settings, focus and white balance. You'll be surprised at the artistic abilities you can develop by mastering the manual control of these settings. You should learn to anticipate the results of the image by using different camera settings and lighting conditions, long before you need to go out on a paid shoot.

Some cameras automatically adjust all of the functions previously discussed. Some cameras can be set to manually control one,

two or all functions. You'll want a camera that allows you to manually adjust every setting individually, because having the iris, color or focus automatically change on its own can ruin the look of your film.

We spent a lot of time on cameras and lenses for good reason. It's the primary tool for making your movie. Now, let's look at how all this technology comes together to create the images you desire.

Exposure Techniques

We discussed the various camera settings individually. Be aware that all of these settings interact with each other to create a specific look to your image. We'll get into that now.

Consistently obtaining the correct exposure and color is a matter of practice. Many factors come into play and these camera settings interact with each other when adjusting one at a time.

There are several camera settings and scene situations that will all affect your exposure. These are: the aperture **F-Stop** setting of the iris, the **gain** setting of the camera sensor, the **shutter speed** setting of the camera, the light intensity of the subject and the distance of the lights from the subject.

Another camera device that affects exposure is called a **neutral density filter**. This is an internal darkened lens that reduces the light striking the image sensor without altering the color setting. When activated, it forces the lens aperture to open wider, making the depth of field more shallow. Not all cameras

are equipped with this device.

As you can see, these six factors can affect the exposure. So which one do you change when you want to adjust your exposure? That depends upon other factors of the image you wish to change in addition to the exposure.

Adjusting the iris by changing the F-Stop setting will also change the depth of field. Most directors prefer a soft background, so going to a wider F-Stop aperture by opening up the iris will accomplish that. But now you'll have to lower something else to compensate for the exposure change. That might be changing the lighting, or adjusting the ISO. The ISO is the electronic sensitivity of the sensor.

The higher the ISO number, the more sensitive the camera is to light. Increasing ISO also increases grain in the image, so you can't go too high before it's noticeable.

Don't forget the shutter speed. That adjusts exposure too, but it also changes the effect of any motion in the subject. Too high, and there is a staccato effect. Too low, and

moving subjects will succumb to motion blur. They will look blurry when they move.

Every lens has a sweet spot. Typically, the lens shows its flaws more at the limits of its settings than it does at a medium setting.

The neutral density filter reduces light to the lens so you can set your lens parameters closer to the sweet spot while still maintaining a correct exposure. Again, not all cameras have a neutral density filter.

Experiment with all your exposure settings and see how they interact. With practice, you'll be able to determine which is the best adjustment to make for the individual scene.

Some cameras have a feature called **zebra stripes.** This feature will assist you in setting the correct exposure when it's hard to do so simply by using the camera viewfinder.

Sometimes exposure is difficult to access through the viewfinder if there is a bright, overexposed part of a face. A yellow shirt may take on a white hue as it's overexposed. The zebra stripes function superimposes black and white stripes in the viewfinder

wherever something is overexposed beyond the range of the image sensor. Naturally, the zebra stripes don't show up in the recorded video itself, even if the shot is overexposed.

Video Peaking is a feature that assists lens focus. Sharp focus can be difficult to obtain manually when using the flip out LCD display or the camera viewfinder. Often, those devices are too small to achieve critical focus by sight, especially for those of us with less than perfect close vision.

Video peaking allows a predetermined yellow or red color to display along the edges of objects when the perfect focus is set. Naturally, these colors don't show up in the recorded video.

As you can see, there is a great deal of interaction between many camera settings. There are also many advanced camera features on professional cameras that are beyond the scope of the beginning film maker.

How is one to determine the best settings? That, my friend, is what makes the **director of photography** (**DP**) earn their keep. A

director of photography is the person responsible for setting up the camera(s) and the shots. In a small production, the DP may also work the camera, but in Hollywood, the DP only directs the camera operator(s).

Knowing which parameters to change and when, only comes with practice and experimentation. There are far too many different cameras, features and lights to cover every setting within the scope of this book.

I urge you to play around with your camera settings and lights, and learn the characteristics and limitations of your particular camera. Only by hands-on experience will you truly learn to create the desired look for your scenes.

This book is mainly for your reference to the terminologies. No book can show you the best settings for every shot. You will learn that only with practice.

Chapter 7 – Creating Shots

Framing Your Shots

Every shot you create should be intentional. Most films open with a wide angle shot so the audience can see the setting where the action will take place. After such establishing shot, the director will usually concentrate on a close up of someone or something.

Each shot is usually no more than ten seconds long, depending upon dialog and other factors. There are no hard rules for this, however. Some films have been made with shots that last several minutes as the camera moves around to emulate the perspective of a person walking through the scene.

The recent movie, Birdman, is a perfect example of this. The first shot lasted almost twenty minutes before the next shot was blended in to make the film appear as if it was one, long shot from beginning to end.

Typically, your film will be comprised of many

short shots that will all be stitched together in sequence during the editing process to tell your story.

Creating shots that will blend together seamlessly in the editing suite is a matter that takes lots of practice. Even though we are not editing on set, you must use these filming techniques to allow the editor to have the correct material to create smooth edits.

Generally speaking, you will vary your shots in some manner so that shots don't '**jump**' from one to the other and drag the attention of the audience away from the story. This is done by varying either the **focal length** of the lens between shots, or by changing the camera angle between shots.

A good rule of thumb to prevent unsightly **jump shots** is to vary the camera angle by at least 40 degrees between shots, or vary the focal length by at least 40 percent, or both.

Let's use a simple example. You are shooting a scene where two actors are sitting at a table across from each other. Shot one opens as a **wide angle shot** from a distance away, centered evenly between both actors.

You can see the table, both actors and enough surrounding background to know where they are.

As actor one speaks, the next shot might be a **close up** on the face of that actor. Not only will the framing of the shot be closer, but the angle of the camera will change so you see his face head on as opposed to the profile in the opening wide shot.

As the next actor speaks, the camera will come close on that actor, from yet a third angle that allows their face to be seen head on. As the dialog proceeds, these close up shots will alternate back and forth from one actor to the other, with a wide shot maybe breaking in once or twice.

Moving the camera for every line of dialog would be a tedious and time-wasting effort. In a TV studio, they would have three cameras, one each on the actors close ups and the other camera for the wide shot. The dialog would take place in real time. Those cameras would be connected to a video switcher operated by a fourth person who selects the active camera. In effect, the editing would be done live, or 'on line',

creating a finished product as the show progresses.

Since films are not recorded live, we can get by with using one camera. This saves the expense of two additional cameras, two camera operators, the video switcher and its operator. But all that camera movement. How do we avoid that?

As I mentioned before, the example has three camera angles. The director will usually first film the entire scene from one angle, probably the wide angle first. The entire scene might be recorded three times from the same angle to give the director the ability to have choices, since some takes are naturally better than others. Then the camera will be moved for the close up of actor one.

The entire scene is performed one, two or three times, depending upon time and budget constraints.

Finally, the entire scene is shot again a few times with the camera now placed in position for actor two. Ideally, the director will now have three full recordings of each camera position for a total of nine full readings of the

scene. It's a lot of work on the actors to repeat the scene the same way every time. However, we only had to position the camera three times.

It becomes the job of the director to pick the best takes, and to provide that information to the editor in order to cut the scenes in the right places. The editor puts it all the scenes together so the finished video looks as if the conversation took place in real time, looking as if three cameras were used. If the scenes are shot and edited correctly, the audience will never know the conversation stopped and started many times.

Now, usually the wide shots are used only at the beginning and end of the scene, with maybe one or two wide shots placed in between the close ups. If the director has planned diligently and knows exactly where he or she wants the wide angle shots, they can save time, as well as wear and tear on the actors, by filming only those wide shots and not the entire scene three times.

The lighting crew will have provided the best positions of the lights for the scene. Once the best lighting positions are selected, they

should not be moved when the camera is moved. Otherwise, the audience may see that the lighting is inconsistent from shot to shot, or that the facial shadows are not in the same places from shot to shot.

The same is true for the sound, which we will dive into later. Ideally, you want the lighting and sound to be consistent throughout the scene, regardless of whether the shot is filmed from close up or far away.

Shot Composition

Shot composition plays a major role in the look of your film. Most people don't look their best from a profile, especially on film. It becomes important to keep both actor's eyes visible in the shot, even when their head is turned.

If you are the actor, you can tell if this is happening simply by noticing if you can see the camera lens with both eyes. If one eye can't see the lens, the camera doesn't see both eyes.

A basic term called the **rule of thirds** was created to provide guidance in shot composition. Seldom do subjects look their best when they are centered in the shot.

An ocean view looks best when it's one third ocean and two thirds sky. An actor looking at someone will look better in the shot if there is more space forward of his face than behind his head. You guessed it; about two thirds in front of him and one third behind.

Recording people is usually most appealing to their facial features when the camera lens

is at eye level or very slightly above eye level, and slightly to the right or left of seeing them head on.

Getting too close to a person tends to make their faces look oddly round. That's because of something called **parallax distortion**. This is a result of the distance from the lens to the center of their face is closer than the lens to the sides of their face. You'll see this quite a bit with selfie shots using a smart phone.

As the camera moves farther away, the facial distance from center to side becomes less proportionate, and the face looks more appealing and lifelike. Six to eight feet away seems to be ideal for facial shots.

Buildings often appear unappealing if you film them straight on. Shooting buildings from an angle will add more dynamic impact to your shot.

Play around with shot composition, and you'll see this for yourself. You can even practice shot composition using your smart phone camera.

Chapter 8 – Recording Sound

Sound is perhaps more important in telling your story than video. If you want to prove this, watch a TV show with the sound turned off. Except for car chases and the like, you won't be able to follow what's going on.

Now, try to follow the show with the sound turned on, but not looking at the picture. You'll be able to follow most of the show by the sound alone, especially if it's a TV series where you know what the actors look like.

Microphone Types

There is a wider variety of microphones than there is of camcorders. Each mic has its own sound characteristics. You'll have to judge which you like best for yourself by trying different mikes, or by reading the online reviews by other buyers. I can't possibly cover the thousands of them in this book.

For use in making films, there are only a few

categories of microphones you will likely use on a regular basis.

The **camera mic** is one which is part of the camera itself. These pick up sounds from all directions.

A **shotgun mic** is a long and narrow device that picks up sound in one direction where it is aimed, and rejects most sound from the sides and behind.

A **lavaliere mic** is a tiny device usually mounted on a person and hidden from view when shooting film scenes. Newscasters often use these, but tack them onto their shirt tabs where they are visible on camera.

A **desk mic** mounts on a small desktop stand and is used primarily as a narrator's mic.

The mic on your camera is nearly useless. It picks up sound from all directions, and captures more room echo than it does voice. You will mainly use the camera mic to capture sound that you'll synchronize to the sound track captured by another audio recording device. Hearing the sound from the

camera mic is a sure sign of an amateur film. Of course, you might have a scene written to depict a beginner film maker, in which case that works.

There are external mics that mount on a camera shoe. They are somewhat directional and work better than the internal mic, but are not truly good enough for movie making.

For most scenes, you'll want to use a shotgun mic. This is a long tube with multiple mic elements placed strategically inside the tube. These multiple elements pick up sounds at slightly different times, and by use of **phase cancellation**, they effectively reduce the volume from the sides and behind the mic, allowing the front of the mic to be very directional.

Phase cancellation is a technique that uses some of the mic elements to cancel out most sound that arrives from behind or to the sides of the shotgun mike.

Audio Techniques

Often shotgun microphones are mounted on a long pole called a **boom pole**. This allows the boom operator to stand out of frame while aiming the microphone at the actor's face.

A good boom operator will find out from the camera person how they intend to frame the shot. This allows the boom operator to get the mic as close to the actor as possible while keeping it properly out of frame.

When using a boom pole, three things are important. One is to avoid the mic cable from slapping against the boom pole. Another is to avoid hand movement from causing unwanted sound from being recorded. The other is to always keep the microphone pointed exactly at the lips of the actor speaking their dialog.

If the actor moves and the mic doesn't precisely follow their lips, then the vocal presence will deteriorate during the shot. That's another sign of an amateur film.

When setting up the mic placement, it should

be done for the widest angle shot of the scene. When the next shot is a close up of the same scene, it becomes a natural reaction to move the microphone closer to the actor. The problem then becomes one of inconsistent sound. There will also be a different sense of vocal **presence**.

Presence is the characteristic that makes the actor's voice sound as if it's right near you, allowing the dialog to sound vibrant and clear.

Keeping the mic the same distance in the closeups as it was in the wide angle shot will keep the sound consistent from shot to shot.

Each shotgun microphone has a certain range from the mouth where it picks up maximum presence and minimum room noise. It's usually a little less than two feet from the mouth.

Top of the line mics like those used in TV studios can pick up good vocal presence from six feet away.

If a shotgun mike is even a little off center from the lips of the person speaking, the

sound loses its presence and the mic begins to pick up more room echo.

A directional shotgun microphone can not be used to record two actors unless the boom operator can move the mic back and forth fast enough without adding his own hand noise or wind noise while doing so. Of course, if the two actors are side by side, this makes it easier.

Since you can't aim precisely at two actors at once, it takes diligence to move the mic silently between actors. That only works if they are close together. Actors in opposing shots should be miked independently and filmed in separate takes.

In order to monitor the vocal presence and also make sure you're not recording flaws such as hand noise on the boom pole or loose cable connections, you must use headphones to monitor the sound. Those that fully cover the ears are best, because they block out the ambient sound and allow you to hear primarily what is being recorded.

Shotgun mics begin at about a hundred dollars and work their way into the

thousands. While any shotgun mike is better than the camera mic, you'll have to listen to a few of them or read the online reviews to make an informed decision about which mic fits best within your needs and budget.

There will be times when the editor needs to fill in some sound between the dialog. Simply lowering the volume to record silence creates what is known as a **sound hole**. A sound hole becomes very obvious to the audience, because there is complete and sudden silence. This is one of the most common mistakes made by amateur film makers.

In order to give the editor the correct silence to use between dialog, we record what is known as **room tone**. Every room, no matter how quiet it sounds to your ears, has its own sound. It might be air conditioning noise, a refrigerator running, or just the movement of air within the room. It isn't dead silence to the microphone.

You will want to always record at least one minute of room tone for each different scene. While recording room tone, it is essential for every person to freeze dead silent for that minute while recording room tone.

For outdoor shots, room tone is referred to as **earth tone**. You'll want to record at least a minute of earth tone for every different outdoor scene.

Shooting outdoors adds another element to your sound. Wind noise. Special fuzzy enclosures called **blimps** are designed to encase the shotgun mic. A blimp will minimize wind noise under most normal conditions. Even blimps can't totally cut out all wind noise, so alternate methods of capturing sound, like the use of body mounted lave mics or rereading the dialog in the post production studio might be utilized.

In extreme wide angle shots, you might not be able to bring the shotgun mic close enough to the actor to obtain good vocal presence. In this case, another type of mic is used.

One such mic is a body mounted **lavaliere mic**, or **lav mic** for short. Lav mics come in wired and wireless versions. A wired mic is always preferable because it isn't subject to radio interference or **multipath noise** like a wireless mic. Of course, wires tend to be annoying if the actor needs to move around

more than a few feet or so.

Multipath noise occurs when the radio signal from the body mounted transmitter reflects off a flat surface like a wall, and arrives at the receiver just a fraction of a second after the direct radio signal. This results in momentary swishing sounds or short audio dropouts.

Diversity receivers with two antennas are able to cancel out most of the the effects of multipath noise by switching the receiver between the two antennas to grab the best signal.

Again, this is another reason to always wear headphones, because you won't notice multipath noise simply by watching an audio level meter.

Lav mics are usually worn by the actor under their clothing. They have a different vocal presence than a good shotgun mic. The disadvantage here is that unless placed well, a lav mic can rub against the actor or their clothing every time the actor moves. Sound technicians use special tape to affix the mic in a quiet spot in the clothing.

Desk mics are excellent choices for recording interviews where a person remains stationary at the desk, like a newscaster. In some cases, it may be desirable to show the desk mic in the shot. Many desk mics are somewhat directional to reduce some background noise, but not as directional as a shotgun mic. A **pop filter** is a thin screen that mounts an inch or so in front of the mic to prevent the puffing sounds of a close speaking announcer.

AGC and Limiter

Some cameras and audio recorders utilize a circuit that automatically increases the recording level every time the ambient sound is low. This results in an audio 'pumping' action that can be quite undesirable on playback.

AGC, or automatic gain control, is often the curse of sound technicians. Many DSLR cameras use this automated volume leveling of the sound, and do not allow the level to be set manually. In such cases, the silent passages between the dialog is pumped up

automatically, also bring the room noise to a higher level.

High end consumer camcorders and professional camcorders have manual volume controls, either on the side panel of the camera or somewhere in the menu system. When using manual level control, it is important to direct the actors not to alter their voice levels beyond the scope of the mic circuit, otherwise the sound will distort.

Better cameras and audio recorders will have a circuit called a **limiter** that reduces loud sounds from causing distortion. This is different than AGC, because the sound level remains constant except for the occasional spike of recording loud sound.

XLR Connections

There are two types of microphone connectors used on camcorders and audio recording devices.

The small consumer cameras have a **1/8 inch mini jack**. This provides an unbalanced

input on a mic wire with one hot conductor and one ground conductor, meaning that electrical interference from cell phones and other devices can emit noise into the mic cable itself. It is for this reason that all cell phones must be powered off and left out of the room where the scene is being recorded. Even in silent mode sitting on a table, the cell phone will automatically ping the towers every now and then, sending buzzing sounds down the mic wire. Only by using headphones will the sound operator catch that.

One way to minimize electrical interference is with the use of a balanced mic wire and **XLR connector**.

The balanced mic wire of an XLR connection has two hot mic conductors. One is positive and one is negative, with a third and separate grounding conductor.

Most electrical noise from outside the XLR cable is canceled out between the positive and negative hot conductors. XLR connectors are found only on professional camcorders, but they do provide cleaner audio connections and less audio noise in

the system.

Some microphones are called **dynamic mics**, because they don't require any external power supply. But some types of **condenser mics** do need external power. Since an external power supply is often impractical, some camera makers put the mic power supply inside the camera. Such power is called phantom power.

Using a mic that requires phantom power on a camera that does not have this feature will result in no sound being recorded. It will seem as if the mic is defective. The true problem is that a phantom powered mic will not work without phantom power.

Conversely, a mic designed for use without phantom power should not be plugged into a powered mic connector. Mic connectors that have phantom power will have a means of disabling power, so that it does not damage the mics that don't need the external power.

Internal or External?

Most DSLR cameras have limited audio capabilities. In such case, technicians will record the sound on a separate audio recorder. While this allows the recording of superior sound, it creates another issue. That is, post synchronization between the camera files and the audio recorder files. For this reason, when using an external recording device and microphone, it is important to also allow the camera mic to record sound as well. You will need this sound in editing to synchronize the two sound tracks.

Some editing software packages have options to assist syncing in post, but often it will be done manually by the editor. In such cases, the editor will use the wild sound from the camera mic to sync with the better sound from the external recorder. The camera sound track will then be eliminated after synchronization has occurred.

When possible, it is always advisable to use a camcorder with good audio control features. This way, you can record the audio on the camera itself. Doing so keeps the

camera sound high quality, and in perfect sync with the video. You won't have to sync to an external sound track. This makes for much less work later in the editing suite.

ADR and Looping

Sometimes it just isn't possible to obtain clean dialog while recording the video. It may be because of too much background noise, or perhaps it's a windy day. In such case, it may be necessary to add the dialog to the sound track later in post production. The process is called **ADR**, short for Automated Dialog Replacement.

ADR requires each actor to come into the studio at a later date. The actor will watch the video and hear the on-set recorded audio in the headphones. He or she will try to re-record and match their new dialog to their dialog that was previously recorded.

The track will loop over and over, giving the actor the opportunity to have many attempts at synchronizing the new dialog with the old. In the days of film, the technician would

create a film loop by taping the ends of the film together, hence the term, **looping**.

While the audio quality is technically better with ADR, the emotion of the dialog from the scene on set is often lost. It also requires a great deal of time and resources to record ADR in the studio, so it's best to get the audio on set whenever possible.

Slating and Logging Shots

Films are typically comprised of many short recordings of each scene. Even a short film might have 100 or 200 files. This can easily become overwhelming later on when it comes time to edit the film.

Without some sort of documentation, the editor will not know which scenes were shot when. They will not have any idea that in scene two, only the first half of take one is good, and that take three is needed to complete the scene.

The way we keep all the information together is through a document called a **log file**. You can use a formatted log file form to keep track of the shots and takes, or you can improvise your own. Make plenty of blank log forms.

You'll need someone to log each shot. Typically, this is done using the log sheet as well as a **slate**. Everyone has seen the title slate with the clapper that slaps down as the director yells action. This slate will contain the scene number and take number. It may also contain the director name, camera

number, camera person and other information.

The camera lens will always focus on where the action is to take place. Then the slate is placed in front of the lens momentarily. It may be out of focus, but as long as it can be read, it's OK. The camera begins shooting the slate, which is then pulled away while the camera continues rolling to reveal the scene in focus.

Someone should be assigned to keep a log of each scene and take, as well as the actor name and the type of shot. They should also label them as best take, good, or error, based upon input from the director. Trying to shoot the movie and also log the shots in between can lead to mistakes.

Time should be allowed for the logging person to document each shot. Rushing ahead before the shot is logged will only result in lost time later.

A shot log might look something like this.

Scene 1, Take 1. CU (close up) Marvin, good take.

Scene 1, take 2. CU Marvin, good first half, missed words after.

Scene 1, take 3. CU Marvin, best take.

Keep in mind that the slate and logged shots should match. If a separate audio system was used, the audio log should match the video log.

If possible, you may also add the file names from the camera and from the audio recorder so you'll know that video file G0012 goes with audio file X188.

Chapter 9 – Editing Your Film

We now come to editing - the part of the film that will take the most time to complete. Long after the actors and the on-set crew have wrapped filming, the editor begins the month or more process of stitching the pieces together. It isn't unusual to spend one or two days filming a short film, and over a month in the editing suite.

Editing is by nature a visual process. It is difficult to learn in a book, especially if you are new to the editing process. For this reason, I suggest getting your hands on an editing system and practice using it with this book as a guide. Chances are, it will be difficult following this part of the book if you're not sitting at an editing computer.

The editing process can either make or break your film. But that statement only carries so far. Without good writing, acting, and shooting, there's little an editor can make better. A film is only as good as its weakest link.

Sometimes, inconsistent shots or audio issues don't become known until the editing process. By then it's probably too late to correct these errors. But extra camera angles, multiple takes and good room tone can become excellent masking tools if the editor understands how to use them effectively.

Almost all computers, and now even some tablets and phones, come with a simple editing program built in. This makes it easier for nearly anyone to arrange scenes in sequence and even trim them. But it takes a highly skilled editor to make those edits look tight and seamless. The goal is to cut the clips together so the film flows freely without drawing attention to the technical aspects of assembling the pieces together.

I can not mention how many times I've seen films at film festivals with blank video frames, sound holes or jump cuts (these will all be explained later). You don't want those in your film.

There are a wide variety of editing programs, and as such, it becomes impossible to describe exactly how every program

performs the editing tasks. However, once you learn one editing program, you'll soon discover there are enough similarities between yours and other systems that will make it easier to learn other editing programs.

In this book, we will cover only the basic editing functions. We will be limited to using generic instructions which can be adapted for any editing software. Our limited course time does not allow us to expand much beyond the basics.

As stated earlier, editing is a visual process, and therefore, difficult to learn from a book. You'll always learn much more and much faster with hands-on experience, so use this book as a primer or a reminder. Get your hands on an editing computer and practice.

Each editing system uses different terminology. Each places their function buttons in different locations. I once needed to flip an image from left to right, and looked everywhere for the 'Flip' function. Only by accident did I discover that the Flip function was called 'Flop' on the program I was using.

Button positioning and labeling is perhaps the most difficult part of editing to remember, and it isn't consistent from one program to the next.

Concentrate your attention on learning the basic editing functions themselves, and you'll soon be able to edit well even when you forget how the function buttons are labeled.

Good Data Housekeeping

Your video and audio files need to be arranged so you can easily find them. I can not stress this point enough. I'm going to repeat it several times in this chapter. Lay out your file directories and your data folders efficiently, consistently, and in a place where you can easily find your files.

All computers have a main drive where the **operating system** of the computer resides. It's usually called the 'C' drive. Your editing software is also installed on the 'C' drive.

Before you even begin the editing process, you'll want to obtain another storage drive, set up as a 'D' or 'E' drive. This can be an externally located drive, or it can be another physical drive located inside your computer tower. Obviously, if you use a laptop, you'll need an external drive.

Whatever you do, **DO NOT** keep your edit files on the 'C' drive of your computer. In the event your computer fails and you have to restore your operating system, you will **LOSE EVERY FILE OF YOUR FILM!**

It is important to know that when using your editing software, if you do not manually specify where to save your files on the external 'D' drive, the editing program will, by default, save your files into the "C" drive. **Don't allow that to happen**, even if it means the only extra storage besides your 'C' drive is a USB stick.

You should have a computer that is primarily dedicated to editing your film. By all means, on a regular basis, you should **BACK UP EVERYTHING YOU DO** on a third hard drive. Drives can fail at any time, and you don't want to lose months of work.

If anything in this section is confusing to you, please find someone in your group who understands this.

As you set up your file directories, you will want to label each folder so that it is easy to find the appropriate video, audio and picture files as you need them. If your film is shot over several days time, it's a good idea to have separate file folders for each day of filming. Believe me when I say from experience, this will make your life in the editing suite much easier.

Each editor will find their own way to accomplish the same task, but here's what I do. I create a master folder on my 'D' drive using the name of the film. In my example, my film is called 'The Godchild'. (That was my first short film).

My master folder will be titled, THE GODCHILD. I use all caps to make it easier to locate the file.

In my master folder, I will add a DATA folder, a MUSIC folder, a RENDER Folder, a BLURAY Folder, a DVD folder, and a SOUND EFFECTS folder. After copying the files from my camera into the computer and starting the editing process, my folders will look something like this.

```
THE GODCHILD
    DATA
        The Godchild.vf
        The Godchild.vf.bak
    SCENE 1
        VIDEO
            00025.MTS
            00026.MTS
        AUDIO
            A006.wav
```

 A007.wav
 SCENE 2
 VIDEO
 AUDIO
 MUSIC
 Song 1.wav
 SOUND EFFECTS
 Door slam.mp3
 Car start.mp3
 RENDER
 The Godchild Rough Cut.mp4
 BLU RAY
 DVD

In each SCENE folder, I will have files for VIDEO and AUDIO for that scene. Naturally, to save space in the book, I only labeled the audio and video files in one scene. But you get the idea. It expands pretty fast as you shoot more scenes.

It is important to know that once these files are created, they need to remain named as they are. Don't change their names. They also need to be kept in the folders that you put them the first time. Don't move the files into different folders, and don't rename folders once they have files in them.

As you edit your film, you will be creating something called a DATA file. This DATA file is an index to each file that comprises your film. The DATA files keeps track of where all your video files and audio files are located.

If you change the name of a folder or a file in any manner after it is placed into a folder, or if you move a file to another folder, the DATA file will never be able to locate them again. Consequently, you won't be able to continue editing.

Keeping your file structure intact and efficient not only gives you the ability to easily find what you need, it allows you to duplicate the entire file structure to another hard drive.

You can use this other hard drive as backup. Also, if you work at home and in a studio somewhere else, you can copy the entire file structure on the 'D' drive of another computer.

Because of the nature of how editing works, once this file structure is created on a second drive, all you'll have to do is the update the DATA files on both computers as you progress in the editing process. This is

because the editing process does not alter the actual video and audio files themselves. The editing process constructs a DATA file that acts like an index of every editing command. The DATA file tells when to start and stop playing within each video file.

This is called **non-destructive** editing, because all the camera video and audio files remain untouched in their original form. More about this later.

In my DATA file, there are two files. One is called The Godchild.vf and the other is called, The Godchild.vf.bak.

The first file with the vf extension is the working master DATA file that contains all of my edit commands.

The second file with the vf.bak extension is a backup DATA file. These files are exclusive to an editing program I use called Sony Vegas. Other editing software will use different file extensions than my examples.

For my needs, I find Sony Vegas to be far more efficient to work with than any other editing program. This is partly because

Vegas uses the MTS video files (which are smaller) and it does not require additional time for transcoding and rendering the files during the editing process.

Rendering is the process of copying the multitude of small audio and video files to creating one large file.

With Vegas, I only need to perform the render function when I finish the entire editing process.

You will find other editors who prefer Adobe Premiere, Avid or Final Cut Pro. It's a personal choice, just like Chevy verses Ford.

Once you become proficient in the art of editing with one program, it isn't very difficult to learn another editing program. They all perform pretty much the same tasks. Only the buttons and labels are in different places, and that's really what you need to learn when you switch editing software, assuming you already know the editing process itself.

Since this is a beginner course, I will not be covering much more than the basics of editing plus a few additional techniques.

Learning every command and button of any editing software program can take hundreds more pages and an entire school year to learn.

Now that all the video and audio files are placed where you want them, you can begin to edit your film.

In the following examples, I'll be referring to Sony Vegas. Naturally, other programs might use different terms for the same functions.

The Editing Time Line

Most editing programs use what is called an **editing time line** to interface the computer with the editor. Recently, Apple changed Final Cut Pro away from this feature, and many editors abandoned the program for incompatibility and not wanting the new learning curve of a different user interface.

The photo below shows the entire time line of a short video project using Sony Vegas editing software. In this example, we can see hundreds of audio and video elements dispersed on six independent tracks; two video and four audio. Track 1 and track 6 have only one file each. This may be difficult to see in the printed book.

The time line is a highly visual way to edit, both for video and audio. Once learned, it is easy to visualize where each file belongs and how it relates to the other files. In time line editing, each video file is located in time sequence along one, long, horizontal track. Under the video track is usually the main audio track.

If you recorded the audio on the camcorder, the main audio track will automatically be in sync with the main video track.

If you used a separate audio recorder, it becomes somewhat of a task to locate the matching sound file, synchronize it with the video file, and then trim off the excess parts of the audio file that extend before and after the video file.

It is difficult to synchronize audio made on a separate recorder because the audio and video recorders may not have been started at the exact same moment during the recording process.

Once the video and audio files are

synchronized, you will need to lock them together. This is done so that when you slide the video files on the time line to edit them, the audio files will slide in sync along with the video.

The Master Data File

Going back to the process of non destructive editing, this is how it happens. Each time you perform an edit, or make a change to an edit, add another video file into the time line, etc, the file in your DATA folder is updated with these changes.

Even though your project may contain hundreds or thousands of video, audio and picture elements, **all** of your editing work resides in one, single **Master Data file.**

The DATA file consists of an index of information that points to the video and audio files. It creates commands like, start playing file 00025.MTS at 00:00:36:29, and stop playing file 00025.MTS at 00:00:41:03.

The first two numbers **00**:00:36:29 designate the hour, the next two, 00:**00**:36:29 designate the minute, the next two 00:00:**36**:29 are the second, and the last two 00:00:36:**29** are the frame number. There are 30 frames per second, so each frame is 1/30 of a second long.

In this example, the video file 00025.MTS begins showing on screen at 36 seconds and frame 29, and ends showing at 41 seconds and frame 03. The result is that video file 00025.MTS, which might be seven minutes long, will only show on screen for 4 seconds and 4 frames. This is why we call this process **non-destructive editing**.

After your edit has been made, the original file 00025.MTS is still seven minutes long. You didn't actually cut the original file. All you have commanded the program to do is to play part of the seven minute file and disregard the rest. The data file has commanded that the seven minute file only plays for 4 seconds and 4 frames.

To repeat, what the data file is doing is commanding the video file to begin and end playing at specific times. Visually, this is displayed as a small box on the time line. It shows up as if file 00025.MTS is only 4 minutes and 4 frames long. As mentioned before, this 'shortening' of the file on the time line display is simply a visual reference for the editor. The actual file 00025.MTS has not been altered in any manner.

Each time you click on the Save button, the Data file and its corresponding backup Data file, is updated with the edits you have made to that point.

It should be noted with caution that if something happens to your data file, you will **lose all your work**. In that regard, it is a prudent practice every so often to manually go into the DATA folder and copy those two Data files onto another file or a USB memory stick. It is possible for the computer to corrupt a Data file during the save process. It does not happen often, but if it does, you will surely wish you followed this advice.

There may be times when you'd like to continue editing your project at home, but all

your work is saved on a computer at school or at your studio.

In order to do this, you will need to prepare your home computer with all the video, audio and photo files. You must duplicate the file structure exactly the same way it is set up on the original computer. And, of course, you must have the same editing software and version on the home computer.

You only need to set up the home computer this way one time. This is also an excellent means of backing up your entire file system in the event of a major computer failure, or even from theft of the computer.

Once the file structure is re-created on the second machine, you will only need to copy the updated data file and place it into the same DATA folder in your home computer. By doing this, your home computer now has all the updated editing work you accomplished on your first computer.

As long as you didn't move or rename any of your folders or files, you can continue editing your project on your second computer. By emailing the updated Data file back and forth

to yourself, or carrying it on a USB stick, you can copy the latest updated data file into the DATA folder and maintain editing the latest version of your project on the second computer.

Important to note is the fact that you may share your editing progress with as many editors as you like, as long as they each have the complete assembly of audio, video and picture files laid out exactly as they are on the original computer. After that, all you need to do is send them the updated Data file each time you perform more edits.

As you progress in the editing process, you may find yourself adding more music files or more sound effects files into your project. You might even shoot additional video. Of course, you will have to add all those files into the same named directory folders on all the computers used to edit this project.

Otherwise, when you begin working on the second computer, if you failed to add the new music and video files to the second computer, the Data file will look for those files and not find them. You will get an error message to the effect of, "Music File 1 not

found".

Don't worry. You can add all those new files when you remember. But you can only continue editing on the other computer after you update the list of files.

All you need to update your project on each computer is the latest copy of the Data file. Since the Data file is very small, it becomes easy to email it to yourself, or put it on a thumb drive, or even upload it to a cloud server.

This way, you have the latest copy of you data file backed up in case it becomes corrupted or accidentally updated with an older version of itself. Don't laugh. It happens. And it's a heartbreak if you don't have the backup, because it can mean days, weeks, or months of doing everything all over.

I can not stress how important it is to constantly back up your data file. It represents all of your long, hard hours of work.

Your First Edits

In the examples below, I'll be using Sony Vegas, version 11, which I have found to be the most reliable, simple and time-efficient editing software for my needs. Later versions of Vegas 12 and 13 have replaced simplicity with commands that are more elaborate. The good news is you can Google 'Sony Vegas 11' and download a fully working copy for free. You can use it unlimited for 30 days before having to buy it, but even then, it's very inexpensive.

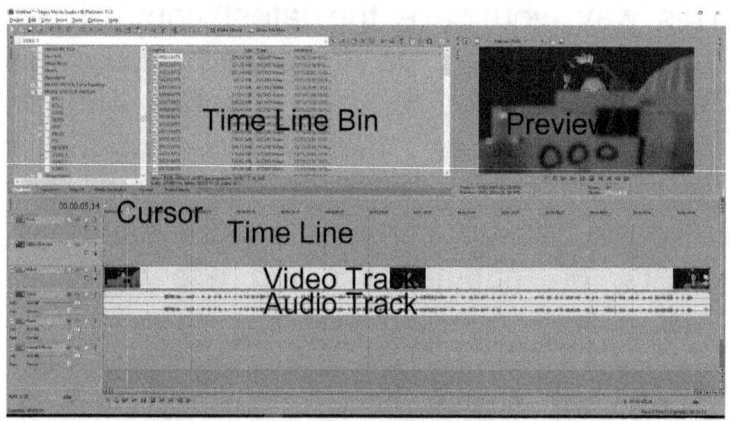

Now that we understand the basic theory of editing, let's begin with a simple project. In this project, we will drag one file from the **file bin** into the **time line**. We do this by left

clicking on the file in the bin, holding down the left mouse button as we drag the file to the time line. Release the button and the file displays in the time line.

The editing software will display that on the time line as two file squares. One will be the video file and the other, underneath, will be the matching audio file. At this time, both files are synchronized, so if you play that file in the time line, you'll see the video in the preview screen as normal.

Let's see what we can do with these two files. We can lock them together so that when we move either the video or audio, the other stays in sync.

First, click on the video file. It should turn blue. Then, hold down the **Ctrl** key and click on the video file. It will turn purple. Now you are ready to go into the menu and lock the audio and video together, (or unlock them if they are locked).

The following image shows the nesting menu structure of how to do that. In case you can't see it in the small image, the menu commands are **Edit, Group, Crate New**.

When both files remain in sync, they show up as white boxes.

In order to move these files right or left, place the mouse arrow over the desired file, click and HOLD DOWN the left mouse button as you drag the file right or left.

If you drag the unlocked audio file to the right as shown below, the audio and video are now out of sync. They will show up as pink boxes on the time line (they probably look light gray in this black and white book).

On the next image, take a look at the **wave form** in the time line close up. You will see the wave forms are straight through the audio file for a bit. You'll then see where the lines expand into a jagged looking wave form. This is the point where the audio begins.

Drag the cursor to just a tiny bit before the waveform begins. Press the letter 's' on the keyboard (for split). If the audio and video files are locked together, this will split the video and audio files at the point just before the audio starts. If the files are not locked together, only the video file will be split. If you want the audio to be cut at the same point,

you'll have to move the arrow to the audio file and split that as well.

You may now remove the unwanted parts of the file (with no audio) so that the remaining part of the file will begin playing right where the audio begins (actually, a fraction of a second before, so the sound isn't cut off). The image below shows the result of cutting the files and dragging them both back to the beginning of the time line so the video starts right away. Had we not dragged the video back, the screen would be blank for a few seconds where the video had been removed.

You may wish to fade-in the video. This is done by grabbing the upper left corner of the video file and dragging it to the right. You will see a dark blue diagonal line from the left bottom to the top right of the fade area. This might be difficult to see in the black and white book, but it designates the start and stop of the fade.

Suppose you want to cut away some of the video without disturbing the audio, and without knocking the audio out of sync? This is accomplished by first making sure the audio and video are unlocked. Then, you will click on the video file at the left edge, but in the center of the left edge, and drag that

edge to the right. This shortens just the video file, while the audio file remains intact and in sync. See the next image.

Adding More Video

The next function you'll perform is adding another video file. The following image shows a second file added to the first.

If you do not wish to add fades or effects between the files, you may leave them as they are. This is called a **hard cut**.

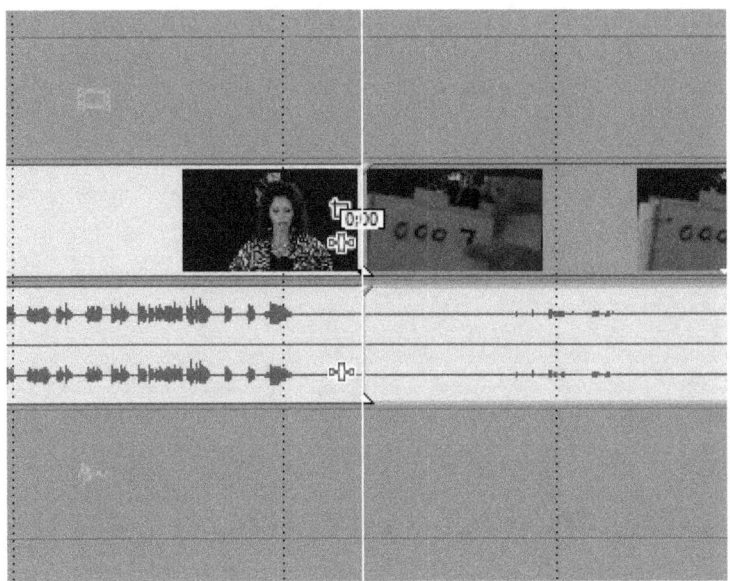

You may decide to trim the end of file one, or the beginning of file two, or both. Then, you can drag the two files together again after you trim them. Be careful not to leave a gap

between the two files.

Creating Fades

The next function you may wish to perform is to fade two files together. Let's presume that the audio and video are locked together. All you do is select the second file with the mouse, hold down the left mouse button and drag the second file into the first. The more you overlap the two files, the longer the fade will be. This is shown in the image below.

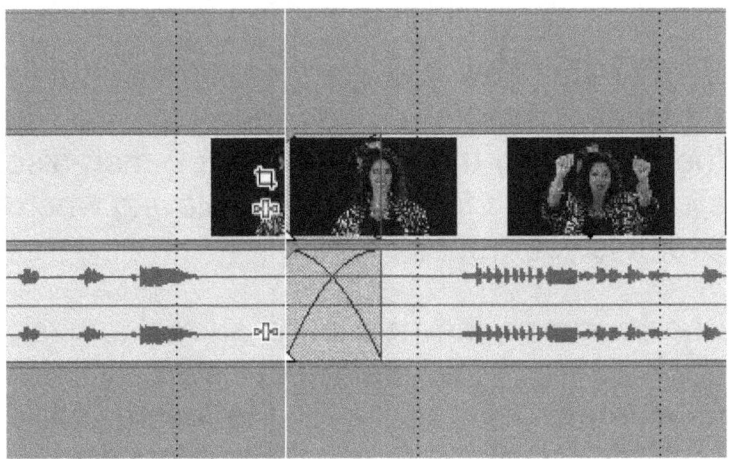

Adding Music

Sometimes adding music to a scene helps establish the mood. You will need to go back into your file bin and select the folder you should have labeled 'MUSIC'. Here, you'll find your selections of songs and other audio files you may have copied into the MUSIC folder. Drag one of the songs into your time line, but in the track below the existing voice track.

If you recall how you dragged the video files together to create a video fade, you can do the same with the audio files. You may also slide the music file so it begins playing where ever it is you want it to start.

The image on the next page shows a music track added to the time line. Should you wish to change the volume of the entire track, grab the top of the music file with the cursor, hold down the left mouse button and drag the line down. The lower you drag the line, the lower the volume becomes. You'll see the audio wave form become smaller as you drag the volume bar lower.

Since the music file is independent and not synced to the video file, it does not turn pink when you move it. The 'sync', so to speak, comes from your own artistic ability to determine where the music should begin. You may then manually lock the video and audio tracks together, using the same technique as we did between the sound track and the video.

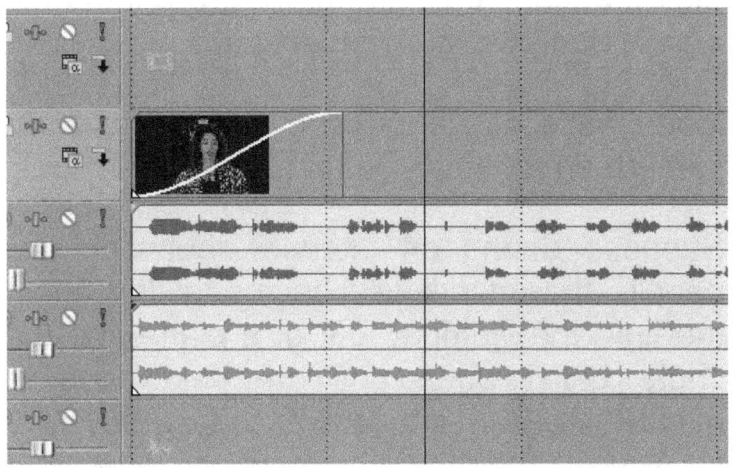

Split Cuts and Video Inserts

There will come a time when you will want to insert different video over your soundtrack than what was originally recorded.

Suppose you shot a three minute video of someone speaking about their past. Three minutes of their head shot would be quite boring. As your subject reminisces about their first car, you want to show a photo of it. This is done using an **insert edit**.

Insert edits can also be cut in to cover up camera errors lie an out of focus shot.

Suppose during an interview between two people, the interviewee begins talking about the time they jumped out of a plane and the chute didn't open until the last possible minute. As the interviewer gasps in awe, you'd want their facial reaction on video, but would also not want to cut into the audio of the interviewee. Here, you would cut away to the interviewer's video while allowing the audio track of the interviewee to remain intact. As the interviewee continued telling their story, you'd see the reaction of the interviewer.

Adding Titles

To round out your project, you may wish to include a title. Titles may be added so they precede the video, and are simply white letters over a black screen. You may also wish to have the titles fade into the video, or even overlap the video itself.

You can change the fonts, sizes and positions of the title in relation to the video screen. As you make your changes, you can see the results in real time in the preview window and observe your results in the video preview video.

In Vegas, you create titles by clicking on the tab below the file bin, marked **'Media Generators'**. You'll see a list of title functions on the left, and some icons on the right. For the sake of easy learning, stick with the most basic titles for now. You can experiment later with the fun stuff.

At the bottom of the list, click, hold and drag the selection called 'Legacy Text' into your time line. You will see the text creation window overlap the file bin. There will be huge, white letters saying 'Sample Text'.

You'll also see the text box form in its own new video track above the existing video track.

In the text window, select the 'Sample Text' and highlight it. Then, you'll be able to use the menu at the top of that window to change your title, change the font and text size, and re-position the text in another part of the screen as you desire. As you do this, you will see the real-time results in the preview video.

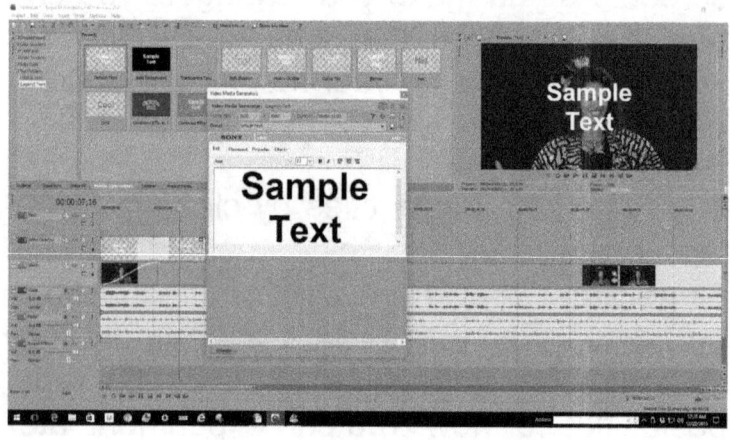

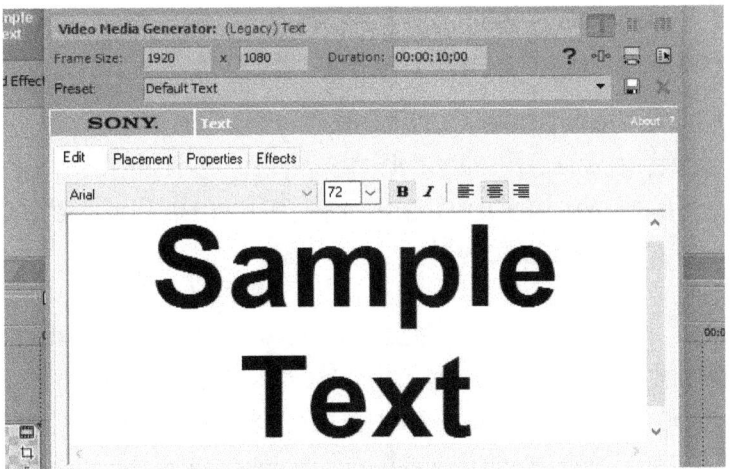

The photo above shows where to change the text size, create bold text or italics, or center the text in the middle of the screen.

There are far more complex selections that can be created in Vegas, but for now, we will stick to the basics.

Rendering Your Project

Once you have completed your project, you'll want to be able combine all the small files on your time line into one large file or DVD disk so you can show it.

As it sits now, you can only view your finished video in the Sony Vegas editing program. This is because it resides within Vegas as a proprietary collection of video, audio, photo, titles and transition files called **elements**.

The process of bringing all these elements together and converting them into one, complete, portable file or disk is called **rendering**.

Finished video files can be rendered into one of many different formats. The most highly recommended format is an **Mp4** file, since these are compatible with almost all computers as well as YouTube, Facebook, tablets and smart phones.

Creating an Mp4 file that is 30 frames per second, 1280 by 720 pixels in size, is perhaps the most compatible file of any type.

This size Mp4 file should play on almost any device that plays video files. Naturally, you'll want to experiment with other sizes and frame rates to see what looks best on your own device.

When you are ready to render your file, here's how you do it. At the very top and near center of the Vegas screen is a tab called 'Make Movie'. Click on this tab, and select 'Save it to My Hard Drive' from the choices. This will bring you to a drop-down menu with hundreds of choices.

Scroll through and make your selection.

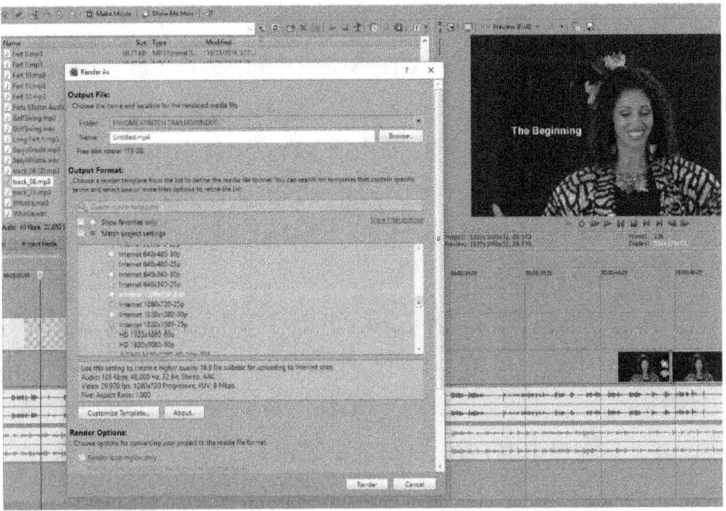

Find the 'Browse' button at the right top corner of the render window. Click on it. Give your project a name in the selection box at the top of the menu. You may also wish to select the folder where you can locate your video, such as the **'Render'** folder you created in your project files.

At the bottom of the menu, press the **'Render'** button. Depending upon your project length and the screen dimensions, this could be a few minutes to several hours.

If your rendered file does not play in your device, try re-rendering to a file that is compatible with the device on which you wish to view it.

It is impossible to create one, single file that will cover every playback need. You might have to render your film several times. Once for the master Blu Ray disk, once for the YouTube upload and once for your phone.

If you need to change one thing in your film, even something as simple as a misspelled name in the credits, you'll have to re-render your entire film all over again.

Going Further with Editing

Sony Vegas is a powerful editing system. We have merely scratched the surface of its thousands of commands and capabilities. Almost anything you can imagine, Vegas can do. But we have to draw the line on instruction somewhere, and this being an eight hour class, this is about as far as we can go for now.

Vegas has multiple means and shortcuts it uses to performing the tasks you wish. Often, you will find two or three ways of accomplishing the same tasks in Vegas. You can learn more about these and other functions by searching for Sony Vegas tutorials on YouTube.

It really is quite difficult learning how to edit from reading a book. You need to see the edit process in action and run it with your own hands to truly understand and grow as an editor.

Someday when you advance in your film making and editing abilities, you'll want to share your work. This is most easily accomplished by creating DVD disks, Blu

Ray disks, Mp4 files or by uploading your film to Facebook or Amazon. All of this can be done using Sony Vegas or one of several other editing programs.

I encourage you to follow up and experiment with editing on your own. Many of the functions you wish to do will be easy to locate simply by reading the menus and playing with the program.

Chapter 10 – Marketing Ideas

Every film maker dreams of coming up with the next big blockbuster film and earning large residual payments for the rest of their lives. I have mentioned before that this happens maybe once in, oh, I don't know, a million? Still, there are ways to market your film on your own and at least bring in some income while at the same time, getting exposure for your film.

I'm sure you know about YouTube. If you have an account with Google, you can receive revenue from the ads Google places over or before your film. Don't get too excited yet. It takes hundreds of thousands of YouTube hits to begin making any amount of money that's worthwhile.

Facebook doesn't pay you for showing your film, but you can use Facebook for getting the word out. You can buy ads, or simply post to friends and like-minded Facebook groups that might enjoy your film.

It is wise to create a one or two minute trailer

for your film. This is a short teaser that draws in a perspective audience. Facebook and YouTube are great outlets for posting your trailers.

Another popular online venue is Vimeo. Vimeo was created *by* film makers *for* film makers. You may upload your trailer or your complete film for free viewing. Vimeo also has a system in place for you to upload your film into a revenue producing venue.

Amazon is another venue where you have control of the distribution of your film. As long as you comply with their technical standards, you can put your film on Amazon for free and share in the revenue each time your film is viewed.

Once you establish an online account, Amazon pays royalty checks for your films automatically on a monthly basis. The biggest technical challenge with Amazon is their recent requirement for inserting closed captioning into your film. Most film makers are not experienced with doing this, so it often pays to hire a company that's been doing it for years.

Netflix might the rights to exhibit your film if they deem it to be good enough for their platform. They typically pay a one time fee of a few thousand dollars to show your film on a pay-per-view basis.

If you can work with a local theater and the local press, you may be able to hire the theater for a public premiere of your movie. This is always an exciting evening. Friends and family of the film makers usually fill most of the seats during a premiere, making the night even more special for the cast and crew.

You might be able to get the press to bring attention to your film at no cost as a public interest story. Many local papers will publish information about your film for free if it's made by a local film group. They are even more apt to provide free publicity if it's a film made by local students.

Since the advent of High Definition video in the last decade, millions more films are competing for audience attention than ever before. The market is saturated with every genre of film imaginable, and this means your film needs to stand out in order to bring

in any significant and continuous revenue that will support your living expenses. At the beginning, though, you should expect mostly fun to come from your efforts.

Here's hoping you are the one who comes up with the next future blockbuster. If you are so lucky, kindly send me a thank-you note for this book and two tickets for a front row seat at your movie premiere.

<div style="text-align:center">End</div>

To my students:

During your use of this book, should you encounter any errors, or feel that something else should be included, please feel free to email your concerns to beelinepublishing@gmail.com.

The author makes updates on a regular basis, and looks forward to your input.

More Books

For more books by this author,
please search
Rick Bennette at <u>Amazon.com</u>

Just Plane Gone
Take My Heart
My Little Angel
Expectations
Tough Love
Aliens In Paradise
Last Chance
Two Suns
The Genie Down the Street
Orbs
Aliens
Moon Boys

www.ingramcontent.com/pod-product-compliance
Lightning Source LLC
Chambersburg PA
CBHW071422180526
45170CB00001B/184